Terence Pepper is Curator of Photographs at the National Portrait Gallery, London. His previous publications include books on Norman Parkinson, Lewis Morley, Dorothy Wilding and Horst P. Horst. He has also written *The Man Who Shot Garbo: The Photographs of Clarence Sinclair Bull, Limelight: Photographs by James Abbe* and *High Society: Photographs 1897–1914*.
Roy Strong, writer and historian, was Director of the National Portrait Gallery, London (1967–73) and of the Victoria & Albert Museum, London (1974–87). In both institutions he pioneered the acceptance of photography and inspired the formation of major photographic collections. He was a personal friend of Beaton.
Peter Conrad was born in Australia. Since 1973 he has taught at Christ Church, Oxford. His many books include *Modern Times, Modern Places: Life and Art in the 20th Century, At Home in Australia* and *The Cassell History of English Literature*, as well as studies of Alfred Hitchcock and Orson Welles. He writes for the *Observer*, and is classical music critic of the *New Statesman*.

Published in Great Britain by National Portrait Gallery Publications, National Portrait Gallery, St Martin's Place, London WC2H 0HE

To accompany the exhibition *Cecil Beaton: Portraits* at the National Portrait Gallery, London 5 February 2004 – 31 May 2004 Kunstmuseum, Wolfsburg 11 March – 26 June 2005

For a complete catalogue of current publications, please write to the address above, or visit our website at www.npg.org.uk

A catalogue record for this book is available from the British Library.

ISBN 1 85514 514 6 Paperback
ISBN 1 85514 516 2 Hardback

Senior Editor: Anjali Bulley
Production: Ruth Müller-Wirth
Additional research: Lisa Scully O'Grady
Design: Price Watkins Design
Printed and bound in Italy

Sponsored by HERBERT SMITH

In association with Sotheby's and *Vogue*

Front cover: Audrey Hepburn, 1954 †

PICTURE CREDITS
Every effort has been made to contact copyright holders; any omissions are inadvertent, and will be corrected in future editions if notification is given to the publisher in writing. We would like to thank the following for permission to reproduce works for which they hold the copyright:

© Cecil Beaton Archive, Sotheby's, London/Collection National Portrait Gallery: fig.1, plates 2, 5, 9, 10, 17, 19, 25, 26, 35, 60, 62, 82, 88, 99, 116, 117, 123, 131, 132, 141, 149, 150
Imperial War Museum: plates 68, 69, 71, 72, 74
Imperial War Museum/Courtesy Sotheby's: plates 51, 52, 67, 70, 73, 75
Imperial War Museum/Collection National Portrait Gallery: plates 55, 56, 66
Imperial War Museum/Courtesy *Vogue* © The Condé Nast Publications Ltd: plate 65
Norman Parkinson Ltd/Fiona Cowan: fig.4
© Reserved: frontispiece, figs 2, 3
Courtesy Sotheby's: plates 1, 3, 4, 6, 7, 12, 13, 14, 20, 24, 27, 29, 30–33, 36, 38, 41, 44, 45, 59, 61, 64, 76, 83, 86, 87, 90-94, 97, 102, 103, 107–115, 118, 121, 122, 124, 125, 136-9, 140
Courtesy Sotheby's/Paul F. Walter: plate 8
Vanity Fair © The Condé Nast Publications Inc./Courtesy Sotheby's: plate 28
V&A Images/V&A Museum/Collection National Portrait Gallery: plates 49, 50, 53, 54
French *Vogue* Les Editions Condé Nast SA: plate 151
Vogue © The Condé Nast Publications Inc.: plates 85, 133
Vogue © The Condé Nast Publications Ltd: plates 95, 126, 146, 147
Vogue © The Condé Nast Publications Inc./Collection National Portrait Gallery: plates 15, 18
Vogue © The Condé Nast Publications Ltd/Collection National Portrait Gallery: plates 21, 57, 63, 96, 129
Vogue ©) The Condé Nast Publications Inc./Courtesy Sotheby's: plates 11, 16, 34, 77, 84, 100, 106, 119, 120, 128, 142–5
Vogue © The Condé Nast Publications Ltd/Courtesy Sotheby's: plates 23, 37, 39, 40–43, 46–8, 58, 78–81, 89, 98, 101, 104, 105, 127, 130, 134, 135
Vogue © The Condé Nast Publications Ltd/Courtesy Sotheby's/Collection National Portrait Gallery: front cover, plate 148
Vogue © The Condé Nast Publications Ltd/Paul F. Walter: plate 22

The majority holding of Beaton's negatives, vintage prints, scrapbooks andcopyright is held by Sotheby's in London. Sotheby's maintain the archive and make it available for publication and exhibition through their Picture Library. For further information on the Cecil Beaton Archive, telephone: 020 7293 5383 or email: piclib.london@sothebys.com

BEATON
PORTRAITS

Terence Pepper

Roy Strong
Peter Conrad

NATIONAL PORTRAIT GALLERY, LONDON

BEATON
PORTRAITS

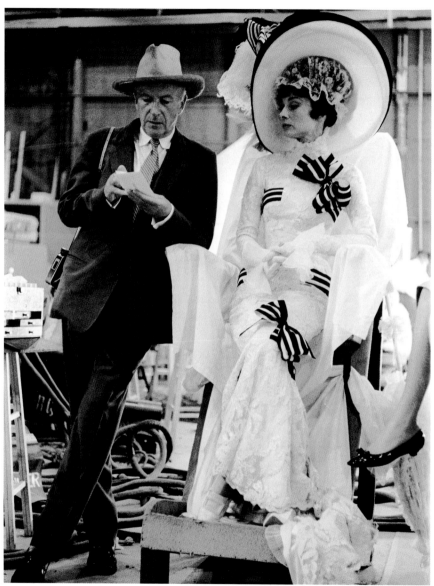

Beaton and Audrey Hepburn on the set of My Fair Lady, *1963*

CONTENTS

SPONSOR'S FOREWORD
Herbert Smith

FOREWORD
Sandy Nairne

7 BEATON PORTRAITS 1928–1968 REMEMBERED
Roy Strong

10 BEATON'S FOREBEARS AND CONTEMPORARIES:
A PHOTOGRAPHIC LEGACY
Terence Pepper

19 PLATES

170 BEATON IN BRILLIANTIA
Peter Conrad

198 BIBLIOGRAPHY

200 ACKNOWLEDGEMENTS

SPONSOR'S FOREWORD

In this, the centenary of Cecil Beaton's birth, Herbert Smith is delighted to sponsor the National Portrait Gallery's significant retrospective of the works of Cecil Beaton, one of the most important and influential British photographers of the twentieth century.

This exhibition, the first major show focusing on Beaton's portraits for over thirty years, contains many of the images that have helped define the twentieth century: from portraits of the rich and famous to those that shed light on a world at war. It provides an opportunity for a new generation to reflect on that momentous century and also to enjoy Beaton's unique talents.

Herbert Smith is delighted to be associated with an artist of such stature, an innovator who succeeded in spanning the generations. As a leading international law firm, our responsibilities extend beyond providing advice to our clients across the world and include a commitment to the community in which we work – whether it be through mentoring schemes in local schools, pro bono legal advice or, as here, supporting organisations who seek to engage diverse audiences with art of the highest quality.

Herbert Smith is pleased to have played a part in making this exhibition happen. We hope you enjoy it.

Richard Bond, Senior Partner, Herbert Smith

FOREWORD

Cecil Beaton's portraits mix a mastery of composition with a winning ability to capture the spirit of those that he admired. Many images are essays in theatrical organisation or design, and many others show the skills of a painter in their tones, contrasts and highlights. He spanned the twentieth century with, as often commented, a way of re-inventing himself for each period, keeping close to the worlds of theatre, film and the visual arts, but also reaching out to the wider realms of society and government.

Looking at Beaton's portraits from the twenty-first century is to see a great parade of the significant names of the twentieth century. But it is also to see a career devoted to life as a form of theatre, an arena for imagination and artifice: theatre being Beaton's first love and the place where he most consistently wanted to work.

It is a good time to examine and enjoy Beaton's work. The comprehensive exhibition created by Sir Roy Strong in 1968, a collaboration with Richard Buckle the designer and with Beaton himself, was a marker of significant changes at the National Portrait Gallery. Thirty-five years later it is possible to stand back and make a selection across the whole of his life and then to introduce his work – already influential on successive generations of photographers working in Britain – to younger visitors and to those who may

only have encountered the most well-known royal portraits or images connected to Beaton's great stage and film design projects, *My Fair Lady* and *Gigi*.

My first thanks go to Terence Pepper, the Gallery's Curator of Photographs for his outstanding work in making this new selection of Beaton's work, exploring, as it does, both the well-known images and those that have remained in the archives. The exhibition is curated with all his conscientious determination to present Beaton for our time. I should also like to thank Sir Roy Strong and Peter Conrad for their perceptive contributions to the catalogue. Many other colleagues at the National Portrait Gallery, who are acknowledged elsewhere, have done so much to turn this great idea into a magical reality and I offer my grateful thanks to them.

Herbert Smith is owed many thanks as the overall sponsor of the exhibition in London. I am grateful to the firm for its enthusiastic support without which a presentation on this scale would be impossible. Sotheby's and *Vogue*, who have both been closely connected with Cecil Beaton's photographic work over so many years, have been supporters of the project from the beginning. Their help has been invaluable in many different ways.

Sandy Nairne, Director, National Portrait Gallery

Beaton Portraits 1928–1968 Remembered

Roy Strong

A S I get older some people who have died live on in my memory while others fade. Beaton's memory remains to me forever green and I think of him often. These thoughts are prompted by anything from glimpsing an historic interior he would have adored to seeing a rose of a variety I recall in his garden at Reddish House in Wiltshire. Nothing can hide the fact that he was vain, ambitious and sometimes vitriolic. But I was lucky to enjoy the generous side of a man endowed with a wonderful and unusual visual perception, attuned to every change and nuance of his period. As a consequence his photographs form an unrivalled panorama of an age (far more than a documentarist like Bill Brandt, for example) of which I caught the tail end, an era that subscribed to elegance and style, believed in king and country, cultivated reticence and the importance of observing a code of rules that framed social life. All of that has gone, but Beaton's photographs are a monument to that vision.

If I had to pinpoint a single event that acted as a turning point in the history of the National Portrait Gallery in the twentieth century, it would be the exhibition *Beaton Portraits 1928–1968*. On 1 June 1967 I succeeded as the Gallery's Director at the age of thirty-one. Looking back and re-reading letters and diaries from that period I find myself a young man who was certainly ambitious but also naïve, bursting with energy and something of a show-off. From the moment of my appointment, I was determined to change the Gallery's profile and along with it the public's perception of the place beyond recognition. Amongst a long list of objectives were two that, by a stroke of luck, converged in the concept of this exhibition. One was for the Gallery to acknowledge the existence of photography and the other that portraits of living celebrities should, for the first time, adorn its walls, something forbidden until then.

I had admired the work of Cecil Beaton ever since I was a teenager. In the post-war years his sets and costumes evoked a world of opulent glamour on stage, which was only heightened by the bomb damage and crumbling walls of the London outside the theatre. I admired too his work as a photographer, those monuments to 1930s romanticism, Surrealism and high artifice with which he presented the Royal Family, the pre-war *beau monde* as well as the stars of stage and screen. What I was unaware of in 1967 was that Beaton was in eclipse. The 1960s had brought a new wave onto the scene, photographers like Snowdon and then the bovver boys, headed by the insouciant David Bailey. The exhibition was to put Beaton back on the map, this time as an Old Master.

I had only met Beaton in passing, when I curated a display of portraits for the great Shakespeare Quatercentenary Exhibition at Stratford-upon-Avon in 1964. That exhibition was one of the series of revolutionary shows devised by the ballet critic Richard Buckle, who was a great friend of Beaton. Beginning with his famous Diaghilev show in 1954, Buckle was to change exhibition- making irrevocably. For the National Portrait Gallery exhibition, the combination of Buckle as designer and Beaton as subject, I knew, would be a sensational one. My first approach was to Buckle, and only three days into my directorship, on 3 June, I would write to my Dutch friend Jan van Dorsten with the news that I had landed the show. The reader will find full accounts of the lead-up to this landmark show in Beaton's and my own published diaries.

Nothing quite like the Beaton exhibition had ever been seen in a public gallery before. The description of the exhibition I sent to van Dorsten, captures its flavour and intense theatricality:

> The programme is like a play: Act 1: A drawing–room pre-war with a
> great frieze of beauties, the Queen Mother seen in the distance through a Venetian
> window flitting across sunlit lawns, Beaton himself looking out of a tin-foil mirror as the
> 'Observer', thirties music playing [Django Reinhardt]. Interlude: the War, a corridor of
> sailors, bomber pilots etc., hung like banners, a bombed-out room; and a vista closed
> with St Paul's arising from smoking ruins. Prelude to Act II: the Coronation. Act II: A
> studio today, a huge studio stove, vast Beaton hat, postcard stand ten feet high with
> twenty photos of Marilyn Monroe on it slowly revolving, a model theatre with
> projections, great racks of portraits, a new one of the queen on an easel (to be released
> on the day of the opening), Elizabethan music playing [Julian Bream] and, as one
> leaves, Beaton today taking one's photo with a flash-lamp bursting every few minutes.
> Incense burns in the last room and a lot of psychedelic light. It ought to cause a furore!

It did. The launch party on 30 October 1968 we owed to *Vogue*, whose brilliant editor, Beatrix Miller, had already dispatched Beaton off to photograph me the previous autumn. The Gallery had never before witnessed such a spectacular gathering: everyone from Noël Coward to David Bailey, Lady Diana Cooper to Patrick Procktor, Sir Frederick Ashton to Anne Fleming, Mick Jagger to David Hockney. The public flocked to the exhibition and its run was extended twice. The queues to get in made national news. The Gallery had arrived.

Buckle, in his commentary in the abridged version of Beaton's diaries, wrote: 'The record breaking show was regarded by members of the profession as the official acceptance of photography as an art.' That comment, I think, still stands. Not long afterwards an enterprising young woman called Sue Davies came to see me, asking what I thought about the notion of her opening a gallery devoted to photography. I said it was a great idea. The result was The Photographers' Gallery in London, still vibrant today. Soon I was able to appoint the NPG's own first Keeper of Film and Photography, Colin Ford, who was to go on and become the first

director of the new National Museum of Photography, Film and Television in Bradford. The Arts Council also stirred and I found myself chairing a sub-committee on photography – not that this was welcomed by the Fine Art Department.

Thirty-six years on, what are we to make of all this? The rise and rise of photography calls for no further elaboration. The Gallery was never to look back. Under Terence Pepper, its commitment to photography burgeoned. Other museums and galleries followed and I was to have a second run on photography with Mark Haworth-Booth at the Victoria & Albert Museum. But what of Beaton and his art? It is, I confess, difficult for me to be objective about someone who became a great friend and who, not long after the exhibition, was to suffer a ghastly paralytic stroke. Since his death in 1980 there has been a steady stream of publications about his career as a photographer, including an authorised biography by Hugo Vickers, a major exhibition at the Barbican and more of his diaries, this time unexpurgated.

Beaton was of course multi-gifted as a designer for stage and screen and as a writer and diarist, but his genius as a photographer was his greatest attribute. As with any great artist his work is endowed with an unmistakable idiosyncratic stamp. In the case of portrait photography (and we must remember that he was not only a portrait photographer) his sitters were presented as their ideal selves and not as they were or could be at their worst. In that sense Beaton can be placed firmly in the great historical tradition of portraiture that presented the idea of a person rather than their often tawdry reality. In its own way this aesthetic premise is as valid as the one that works from the opposite pole, the warts-and-all school that believes the more warts the better. Beaton takes his place as one of the greatest of all twentieth-century photographers, who not only presented an astounding assortment of subject matter but also a kaleidoscopic range of photographic techniques and styles, unparalleled over the course of half a century. All in all if I had to sum up Beaton as a portrait photographer I would repeat the words of Gainsborough on his great rival Reynolds: 'Damn the man, he's so various'.

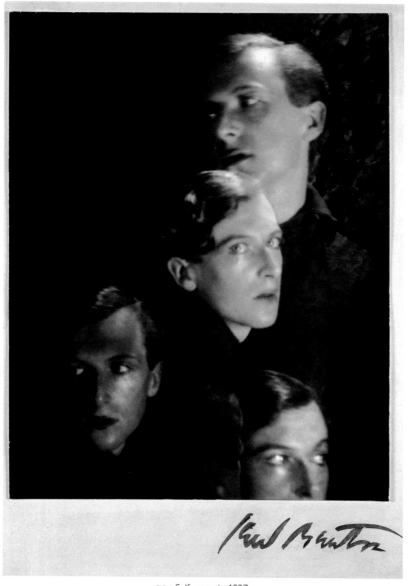

FIG.1 Self-portrait, 1927

Beaton's Forebears and Contemporaries: a Photographic Legacy

Terence Pepper

THE first exhibition of Cecil Beaton's portraits in 1968 at the National Portrait Gallery was, as the then director Roy Strong writes in his essay, a turning point. It brought a new and enlarged audience to the National Portrait Gallery, helping to confirm its dynamic and fashion-conscious director as a key player in the museum world in a revitalised Britain during the Swinging Sixties.

In June 1967, four months after the appointment of Strong as the Gallery's youngest ever director, it was announced in the press, that Beaton was to donate a large archive of his work to the Gallery and that preparations would be made for a full retrospective of his career the following year. This important collection of portraits was separate from the exhibition and has not been seen or generally exhibited since that acquisition. For the first time, in a new technological initiative, this collection can be viewed by the general public on the Gallery's website at www.npg.org.uk and on the Woodward Portrait Explorer in the Gallery's IT Gallery.

In the National Portrait Gallery's founding document, an Act of Parliament in 1856, the types of portraiture that were to be considered for the permanent collection deliberately omitted the photograph. It was not until 1972 when Strong initiated a new Department of Film and Photography, with Colin Ford as its first Keeper of Film and Photography, that the Trustees agreed to change their rules and admit, where appropriate, a photograph to the Primary Collection. The Gallery's Beaton exhibition started a trend or coincided with the zeitgeist for photography shows in other museums and Arts Council-sponsored venues. The Victoria & Albert Museum staged a Henri Cartier-Bresson retrospective in 1969, whilst the Arts Council staged the first Bill Brandt retrospective at the Hayward Gallery, on London's South Bank, in 1970. The following year saw the beginning of photographic auctions at Sotheby's, as well as the founding of the Photographers' Gallery in London by Sue Davies, who had done pioneering work on photography previously at the Institute of Contemporary Arts.

Beaton's photographic achievements were part of a forty-year career, during which he continually managed to reinvent himself. However, as well as his multiple reinventions to keep pace with outwardly changing fashions in clothes and photography, he was at pains to point out that his basic Edwardian taste, drawn from his childhood observations of the world, remained constant and that it was the world around him that recurrently embraced or rejected

his taste and ideals over the years. The 1960s, dominated by an emphasis on the cult of youth, paid witness to the meteoric rise of a new talent-based, less class-ridden society. This mood in some ways strongly resembled the post-war era of the 1920s, in which Beaton had been a key participant. Beaton, with his antennae out for new innovations and ways of seeing, soon became an active chronicler of the fashions along with the new generation of emergent talents.

A younger generation of artists embraced him and became his photogenic subjects, such as the artists David Hockney and Patrick Procktor. Most importantly, the photographer David Bailey repaid Beaton's interest in his burgeoning career by including him (as the only 'aged over 40' subject) in his definitive publication *David Bailey's box of pin-ups* (1965) as well as photographing him. Bailey's admiration and fascination continued into the early 1970s and beyond. Bailey made an important television documentary, *Beaton by Bailey* (1971), which picaresquely records a Beaton photographic session with Hockney and another with the American model Penelope Tree, a later Bailey paramour and muse, on the lawns of Beaton's Wiltshire home, Reddish House. Beaton's career was boosted at this time by the worldwide success of his Oscar-winning work on the film version of *My Fair Lady* (1964). His first diaries, *The Wandering Years 1922–1939*, published in 1961, were well received and revealed him as a significant diarist and reminded the public of his huge success in the 1920s and 1930s.

Beaton's photography has been hugely influential upon several successive generations of photographers. Irving Penn cited Beaton's pared-down portrait of Quintin Hogg (plate 57) as a starting point for his own remarkable series of portraits taken in the 1950s. More recently, the photographers Mario Testino and Johnnie Shand Kydd serve as particularly good examples of Beaton's disciples. Testino has immense flair, as did Beaton, and is acknowledged as the world's leading glamour portraitist of choice for international magazines such as *Vanity Fair* and the international editions of *Vogue*. More recently his work has crossed over to the contemporary art world along with other photographers based in Britain, such as Wolfgang Tillmans, Juergen Teller, Tom Hunter and Martin Parr. Shand Kydd came to notice in the 1990s for his intimate and up-close reportage style, reminiscent of Beaton's portraits of the Young British Artists (YBAs) of the 1920s.

The fascination with Beaton lies in his multi-faceted career, in which he mistakenly placed photography as one of his lesser achievements alongside his greater ambitions to be taken seriously as a painter, designer, playwright, writer, diarist, caricaturist and illustrator. Roy Strong realised that Beaton's real skill was as the portraitist of the age, and that this form of expression would be the most significant for recording the historical figures of the century. It is Beaton's photographs of Edith Sitwell, rather than the paintings of her by Wyndham Lewis, Tchelitchew and others, that define her. With the advancement of Beaton within society circles came invitations to be photographed by the leading studios of the time. These opportunities gave Beaton immediate insight into the working methods of firms such as Lafayette and Bassano. (The fifty-plus large-format cuttings books he compiled of articles mentioning his

activities and successes between 1924 and his death are now to be found in the Victoria & Albert Museum and attest to the incredible skill he had for self-promotion.) The sheer volume of good work that Beaton produced in all media and in particular his prolificacy as photographer marks Beaton out as one of the more extraordinary artists of the twentieth century. Two of his publications were pioneering in the first steps towards the recognition of a history of photography from within Britain. Helmut and Alison Gernsheim's first substantial history of photography did not appear until 1955, and the only two books available when Beaton published *British Photographers* in 1944 were Beaumont Newhall's 1939 exhibition catalogue for the Museum of Modern Art and Lucia Moholy's *A Hundred Years of Photography* (1939). Although Beaton's *British Photographers* is a slight and inaccurate book, it is notable for tackling its subject and for giving clues to Beaton's own influences and photographic heroes, picking out names that the other works overlook. Thus the work of Howard Instead (active at *Vogue* during the 1920s while Beaton was starting out) finds a mention and is the clear source for one of Beaton's earliest portraits in this catalogue (plate 1).

Instead's style was similar to that adopted by Hugh Cecil, another source of inspiration for Beaton, though he later dismissed Cecil as a pale imitator of Baron De Meyer, a giant figure of late Edwardian style and photography. Dubbed 'the Debussy of Photography', De Meyer remained a role model for Beaton. De Meyer is discussed more fully in Beaton's second photo-history book, *The Magic Image: The Genius of Photography*, co-written with the photographic historian Gail Buckland. This substantial book draws on Beaton's lifetime of experience in photography and reflects his wide-ranging interest in the work of all his leading contemporaries.

The other most significant influence on Beaton's early posed photographs was the work of the partnership of Maurice Beck and Helen MacGregor, who dominated the pages of *Vogue* and other magazines in the early 1920s with their fashion studies and portraits of H.G. Wells, Maynard Keynes, Lydia Lopokova, Virginia Woolf and Siegfried Sassoon. Theirs were the first pictures of Edith Sitwell and her siblings to appear in *Vogue* and they even pioneered a recumbent Edith Sitwell pose (that Beaton surpassed in his study of 1927). Beaton generously paid tribute to their inspiration and visited their studios for a double portrait of himself and Stephen Tennant that was to illustrate an article on the new freedoms of the time entitled 'Youth's Byronic Pose'. The portrait was titled *The Riviera Wanderers* by the *Graphic*'s caption writer who described the double and twinned portrait of each being identical to the other and reflected in the mirrored foreground although Beaton's stripes were apparently blue to Tennant's red (fig.2). Beaton also admired the modernist Francis Bruguière – now best remembered for his cut-paper abstractions – for his experiments with the multiple-exposure techniques that Beaton later successfully brought off in a number studies, such as his own four-headed self portrait (fig.1), and those of John Barrymore as Svengali for *Vanity Fair*, Tallulah Bankhead as Sarah Bernhardt, and the Astaire siblings in a multiple floating head composition. Beaton's experiments with multiple exposures were manically revisited with

the disastrous book *Images* (1965), which possibly tried to produce hallucinogenic-type images reflecting 1960s psychedelia. However when the effect was used more sparingly, as in the triple portraits of T.S. Eliot and Harold Pinter (plates 116 and 117), the results have a stronger validity.

Commissions from *Vogue* also forced an adaption, on occasion, to their house style. In the 1920s this meant the elegant control and coolness of Edward Steichen's work, which was replicated by Beaton in the various editions of the magazine. Similarly styled work was produced by Baron Hoyningen-Huene and his apostle Horst. When Beaton worked in Condé Nast's exquisitely decorated apartment (the publishing owner of *Vogue*) on commissioned sittings – such as the fashion study of Marion Morehouse and Lee Miller (plate 15) – it is very much the Steichen ethos that we see emulated. Steichen also, perhaps surprisingly, pioneered the crumpled cellophane-paper backgrounds in the early 1920s, which Beaton was to make one of his early trademarks.

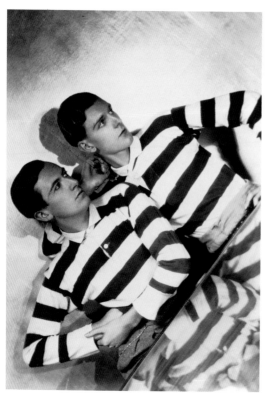

FIG.2 Beaton and Stephen Tennant by Maurice Beck and Helen MacGregor, 1927

Despite these homages to his contemporaries, Beaton's contributions remained totally innovatory and unique. These included his hand-painted cubist sets that he constructed out of card for pictures such as his dramatic back view of Margot Asquith (plate 22), and his depiction of the modernist talent of William Walton (plate 9). These designs were replaced after a few months with patterned materials, ranging from polka dots to stripes and even jungle designs, brought into use for, at one extreme, Lady Ottoline Morrell (posed 'in the Goya manner') and at the other, the fashionably bobbed Iris Tree, wife of the stylish interior designer and avant-garde photographer Curtis Moffat (plates 21 and 23).

The 25-year-old Beaton described his feminine ideal in an interview to the New York *Evening*

Sun in 1929: she should be a 'ripping, ravishing Venus', who should have 'a very long, thin, almost scrawny neck, no chin at all, an abbreviated nose, three cherries for a mouth and big pansy eyes and a general bird-like appearance and heaps of paint, especially around the eyes'. Beaton's ideal was best personified by Paula Gellibrand, the exotic-looking wife of the Marquis de Casa Maury, depicted here in a shimmering, silver-sequinned dress against matching sequinned curtains from her modernist London home (plate 24). Although Beaton's views on feminine beauty did evolve and he was able to appreciate the more conventional looks of a later period, his boyish ideals are shown in his associations with the tomboyish Anita Loos and with her later doppelgänger of the 1960s, Mick Jagger.

Arriving in Hollywood, on assignment for *Vanity Fair* and other magazines, Beaton delighted in the artifice of cinema sets and is famously known to have said that he always wanted to live in stage scenery. He was drawn to the architecture of the back lot. The use of these backdrops set a new trend in Hollywood-stills portraiture. He also made more conventional portraits with the willing collaboration of long-established Hollywood studio photographers such as George Hurrell and Bert Longworth in the MGM studio. Beaton's half-length portrait of Lilyan Tashman, (plate 30), lit by the bright Californian sun against the background graphics of some industrial piping, is a simple, yet successful, *tour de force* that might have been achieved by a photographer and artist such as Charles Sheeler. During his early Hollywood visits Beaton was desperate to meet and photograph the reclusive Greta Garbo, but for most of her career she would only pose for MGM photographer Clarence Sinclair Bull. Beaton made use of Sinclair Bull's portraits to form a collage for his series of articles on Hollywood stars and was so enamoured by one of Sinclair Bull's silhouette portraits that he kept it by his bedside for the rest of his life.

Beaton's trips to Paris in the 1930s and his introduction to Christian Bérard, Jean Cocteau and Pablo Picasso had a considerable impact on his approach to portraiture. His travels to Morocco with Hoyningen-Huene taught him to compose landscapes, but more importantly, Hoyningen-Huene persuaded Beaton to use the Rolleiflex, and it became his most regular machine of photography. Surrealism had a notable influence on Beaton's fashion photography in the mid to late 1930s (also later adopted by British photographer Peter Rose Pulham) and it also found expression in his studio portrait of Gertrude Stein and Alice B. Toklas (plate 76).

One of Beaton's recurring motifs was the rural idyll, first explored in his dressing-up pictures taken at the time of his visits to Stephen Tennant at his home at Wilsford. When Beaton purchased his own idyll, a lease on Ashcombe in Wiltshire he also acquired the perfect setting for his escapist picturing of the many friends that came for fête-champêtres and weekend picnics. Beaton's reverie with portraits shot in landscape settings in the 1920s and 1930s reached their apogee with his photographs of Wallis Simpson in the grounds of the Château de Candé. This sitting prepared Beaton for the royal sitting with Queen Elizabeth taken shortly before the outbreak of the Second World War. These are Beaton's most enduring royal

portraits. They helped to create an image of fairytale beauty worth fighting for and preserving, in opposition to the forthcoming horrors of wartime. Though taken in June 1939 the pictures were not released for publication until after the declaration of war, and together with his portrait of Eileen Dunne in a hospital bed they made perfect propaganda subjects to elicit help and sympathy from those factions in America that played a part in persuading their country to join their Allied front against Hitler.

When Beaton travelled to the Near East and Far East as the Ministry of Information's official photographer, he sent back images of the war effort, and of the attempts to preserve the Empire and its archaic customs that would inevitably be swept away with the Independence of India and other outposts from the late 1940s onwards. The Colvilles appear enthroned in majesty (plate 73) in contrast to the more relaxed and informal settings for their very modern Indian contemporaries: the Maharajah and Maharani of Jaipur (plate 72). Lady Wavell and other wives of British officials were depicted in enormous palaces posed in a style of great pomp. Seen here Lady Wavell, with native Indian help, is broadcasting for the Red Cross whilst her daughter Felicity shows off the grandeur of the imperial experience at the hill station retreat at Simla (plates 67, 68) that Viscount Wavell had made available for wounded and resting Allied soldiers, who were waited on by 300 uniformed Indian employees.

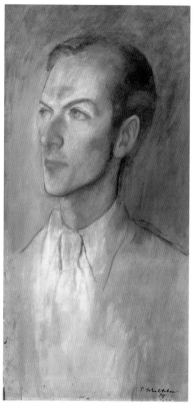

FIG.3 Beaton by Pavel Tchelitchew, 1934

Many of Beaton's official royal photographs from the 1940s onward depended on setting his subjects in a clearly defined, but regal tradition of painted portraiture. His admiration for the high-class studio portraiture of the 1860s, perpetuated by Camille Silvy, clearly had an influence on his later use of backdrops – photographically copied and enlarged from paintings, ranging in style from works by Fragonard and Piranesi to a 1935 winter scene confection by Rex Whistler. He often used these and other backdrops painted by Martin Battersby for royal and society portraiture. In his 1942 study of the then Princess Elizabeth as Colonel-in-Chief of the Grenadier Guards, the background provides an appropriately painterly effect (plate 54). His study of the Royal Family looking at their photographs album (plate 53) immediately

humanised the subjects and helped to underline the key role that the nation's First Family could play in a country at war. In other portraits of the Princesses Elizabeth and Margaret taken in 1942, he posed them as if he might be Gainsborough with his own two sisters, and he found parallels in their lives to such an extent that he spent a number of years writing and designing a play on this theme, first titled *The Gainsborough Girls* and then, *Landscape with Figures*. Apart from the highly praised decor and costumes, the play, with its endlessly rewritten script, was one of the few projects undertaken by Beaton never to be successfully achieved.

The number of beguiling and beautiful portraits Beaton made of leading women of the 1950s is particularly outstanding. Most subjects have their one definitive portrait and yet because Beaton colluded in so many opportunities, we are left with a surfeit. Although he was not enamoured of Elizabeth Taylor personally, Beaton nevertheless captured her breathtaking beauty and exquisite seductiveness (plate 101). Grace Kelly, Ingrid Bergman, Judy Garland and Julie Andrews all possessed different types of allure, but it was Audrey Hepburn, in her first sitting with Beaton in 1954, who created a new type of androgynous gamine with a humorous, yet utterly charming appeal. Other great portraits that Beaton made in the 1950s for *Vogue* include the great lyric contralto Kathleen Ferrier and society polymath Lady Diana Cooper. However, it was only after a falling out with *Vogue* in the mid 1950s that Beaton was forced to move to *Harper's Bazaar* and take on a number of more challenging subjects, such as writers from the American south including Carson McCullers. Beaton was to produce two important portrait compendiums of the 1950s namely *Persona Grata* with Kenneth Tynan and *The Face of the World* in which Tennessee Williams, Saul Steinberg, Charles Addams and Joan Crawford all appear. Beaton's sitting with Marilyn Monroe at his New York hotel in 1956 showed him at his most inventive, and pays tribute to the amazing rapport a great icon can engender in a great photographer. Beaton's simple use of a rose prop and his Japanese-styled bed decoration elicited from the star the vulnerable seductiveness that best characterised much of Monroe's appeal.

A return to *Vogue* in the early 1960s saw more shifts in Beaton's photographic approach. Although previously he had been only an occasional dabbler in colour, Beaton's work in this decade saw him confidently embracing colour in his fashion portraits of Twiggy, Jean Shrimpton, David Hockney and Maudie James. Twiggy could easily have passed as a new Paula Gellibrand, whilst Hockney drawing Beaton at Reddish was resonant of Rex Whistler who had drawn Beaton in a previous country idyll. The 1960s also allowed for the inclusion of a number of studies of male nudes for the first time in Beaton's public work, whilst he also took on the challenging ethos of the Warhol Factory entourage into his visual lexicon.

Beaton was never completely comfortable with the technicalities of photography, and was at his best when others organised the proper lighting to his specifications. Beaton's talents lay with his classically organised framing devices, and producing the unexpected and unusual.

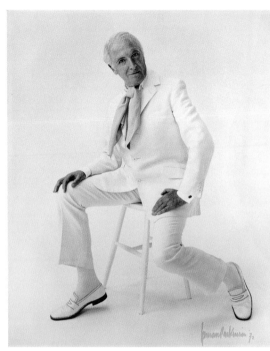

FIG.4 Beaton by Norman Parkinson, 1972

He was obsessed with the grotesque as well as the simply beautiful, but his deepest obsessions were with self-portraiture; a narcissist's complex entertainingly explored over decades coupled with his fascination for the double and the reflected image. This theme is reluctantly explored throughout his career. Even on location as a war photographer in India, Beaton found time to photograph himself in the mirror in the Jain Temple in Calcutta. In 1968 he placed himself in the composition on the set of *Performance* with Mick Jagger and Anita Pallenberg by pointing the camera to the mirror above. Beaton freely discusses his fascination with his own image in *Photobiography* (1951) and he never tired of being photographed or attempting new settings for self-portraiture. Beaton's self-portrait (1938) showing him with his Rollieflex camera, tripod and roses acted as his definitive image for his catalogue for his 1968 exhibition. Erwin Blumenfeld's study taken in the same year, with mirror replacing camera as Beaton gazes down, is a harder-edged alternative with stronger narcissistic and sexual overtones.

Beaton loved his painted portrait by Bérard and used a detail of himself for the cover of his first volume of published diaries, and wrote that this definitive portrait was how he best wanted to be seen. The multiple exposure of 1927 (fig.1) made for a compelling frontispiece for his first exhibition at the Cooling Galleries. Diana Souhami in her insightful and entertaining *Greta and Cecil* (Weidenfeld & Nicolson, revised edition, 1999) decodes his photographs as showing 'merged identity, narcissism and insecurity', which possibly accurately describes this particular image. Souhami tends to agree with the proposition put forward by Philippe Garner that all Beaton's photographs tend to a greater or lesser extent to be, like the works of most great portrait artists, a continuing series of self-portraits in other guises. Writers and critics will continue to debate the real meanings of these, and so many other pictures that Beaton has left us as part of his extraordinary impressions of the twentieth century.

PLATES

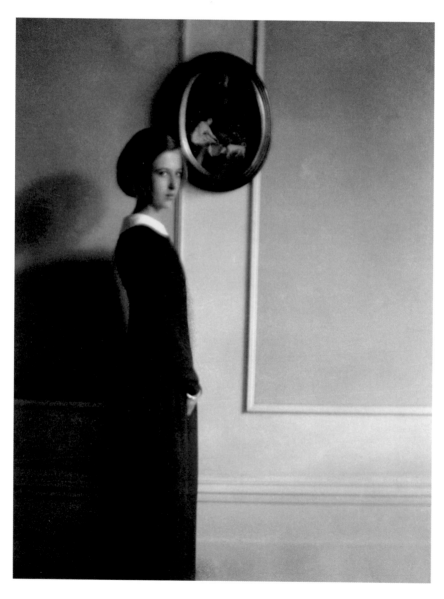

PLATE 1 Baba Beaton, 1922

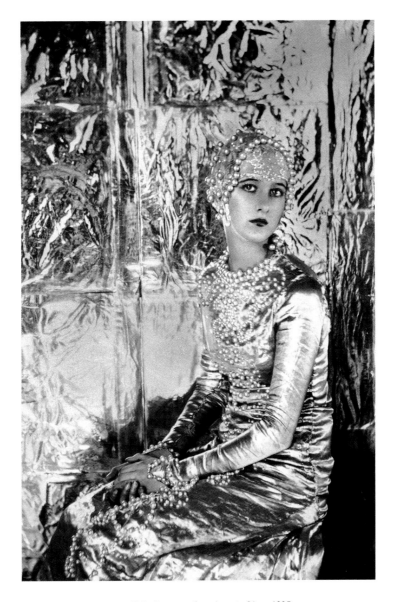

PLATE 2 Baba Beaton: a Symphony in Silver, 1925

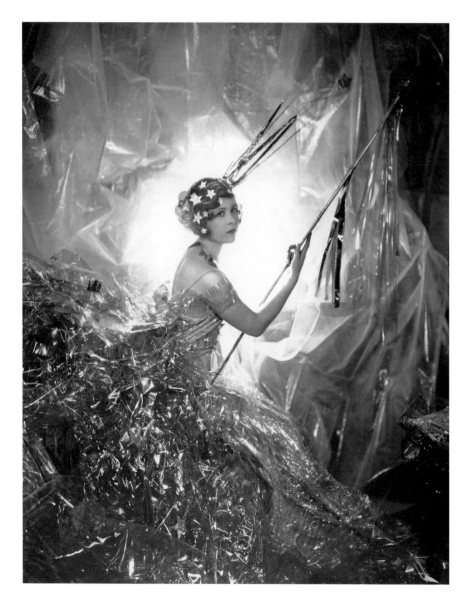

PLATE 3 Nancy Beaton as a Shooting Star, 1929

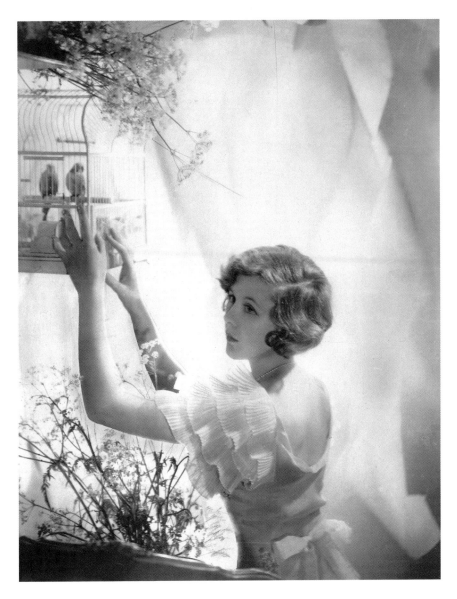

PLATE 4 Nancy Beaton, 1932

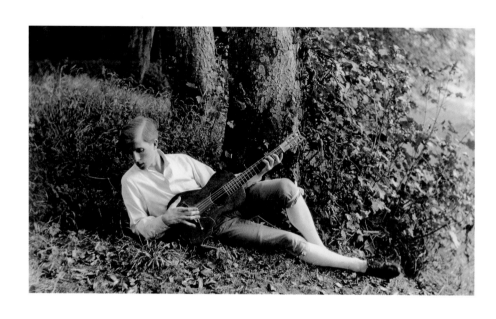

PLATE 5 Rex Whistler, 1927

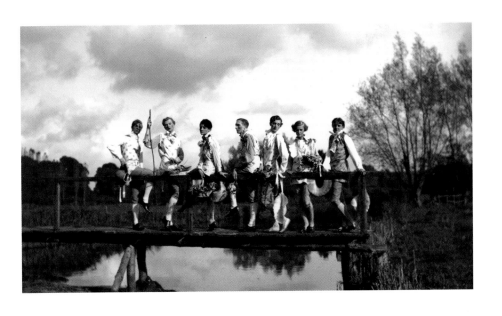

PLATE 6 On the bridge at Wilsford (*from left to right*: Rex Whistler, Cecil Beaton, Georgina Sitwell, William Walton, Stephen Tennant, Zita Jungman, Theresa Jungman), 1927

PLATE 7 Zita and Theresa Jungman, 1927

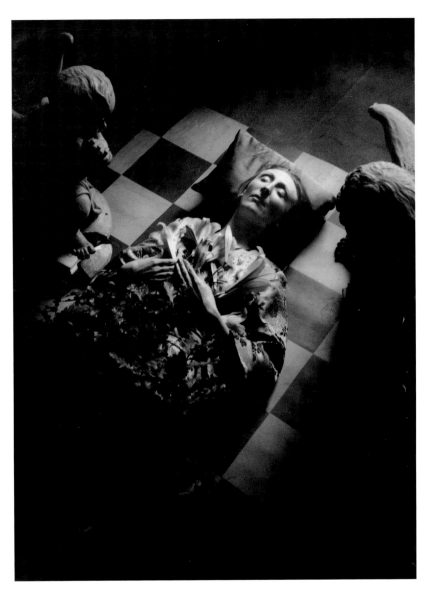

PLATE 8 Edith Sitwell, 1927

PLATE 9 William Walton, 1926

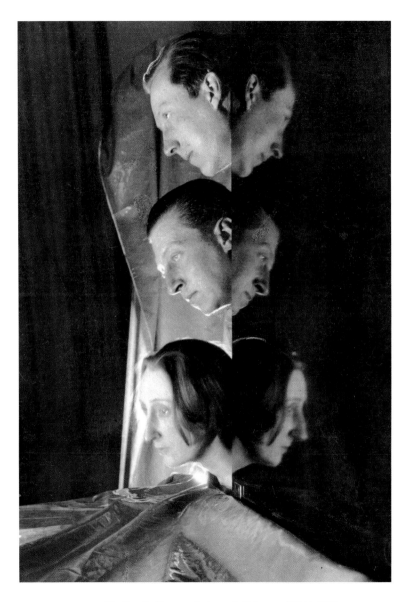

PLATE 10 The Sitwells (*from top*: Sacheverell, Osbert and Edith),1928

PLATE 11 Tallulah Bankhead, 1927

PLATE 12 Soapsuds Group at the *Living Posters Ball* (*from left to right*: Baba Beaton, Wanda Baillie-Hamilton and Lady Bridget Poulett), 1930

PLATE 13 Siegfried Sassoon, 1927

PLATE 14 Stephen Tennant, 1927

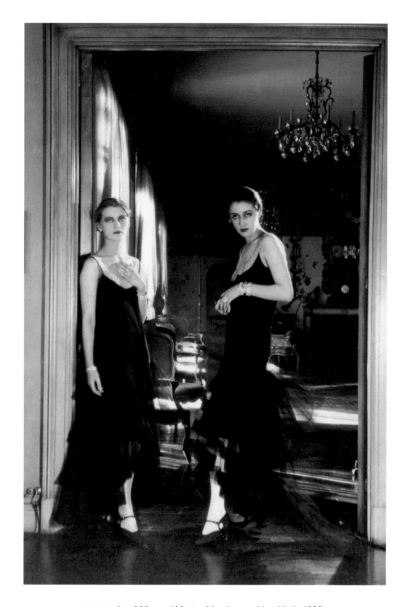

PLATE 15 Lee Miller and Marion Morehouse, New York, 1929

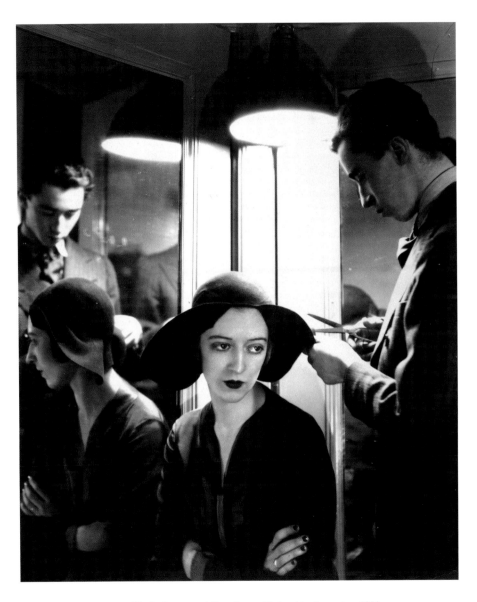

PLATE 16 Charles James modelling a hat on Mariana Van Rensselaer, 1930

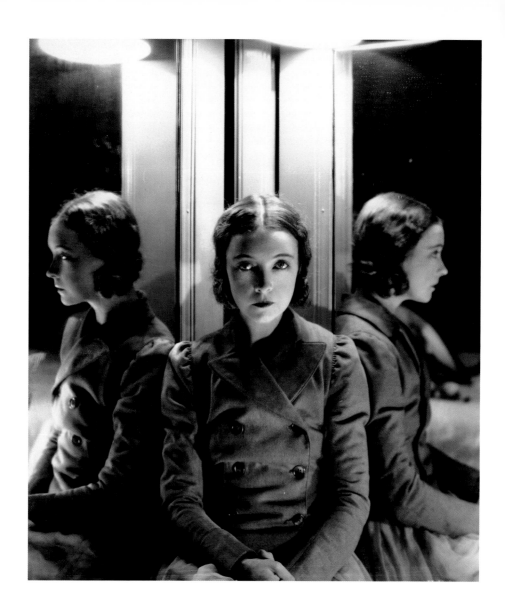

PLATE 17 Lillian Gish, 1929

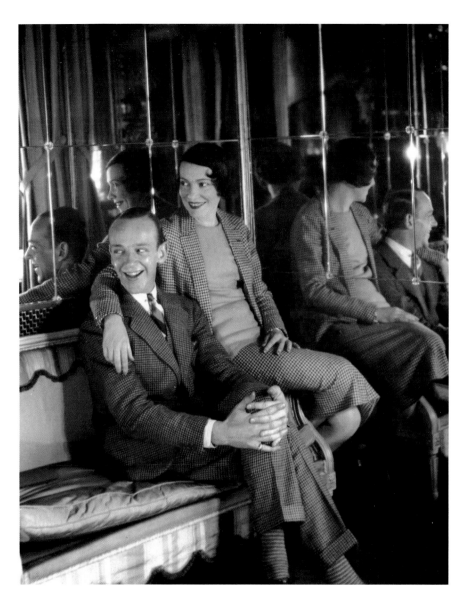

PLATE 18 Fred and Adèle Astaire, New York, 1929

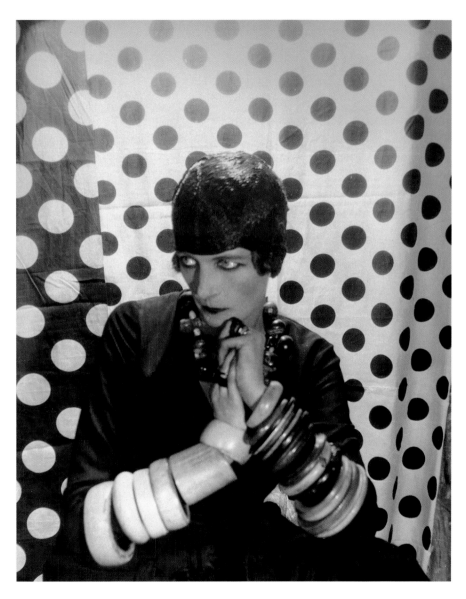

PLATE 19 Nancy Cunard, 1929

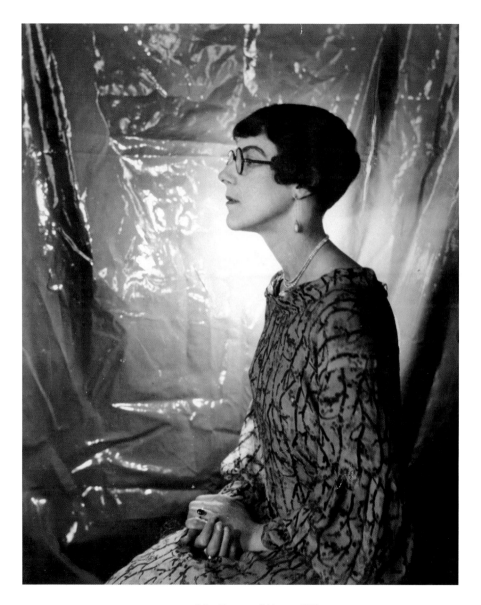

PLATE 20 Sylvia Townsend Warner, 1927

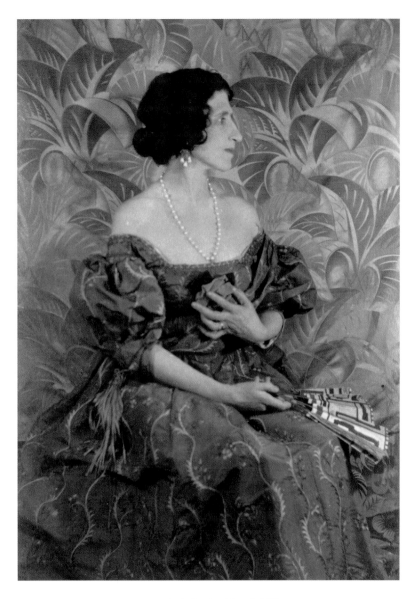

PLATE 21 Lady Ottoline Morrell, 1928

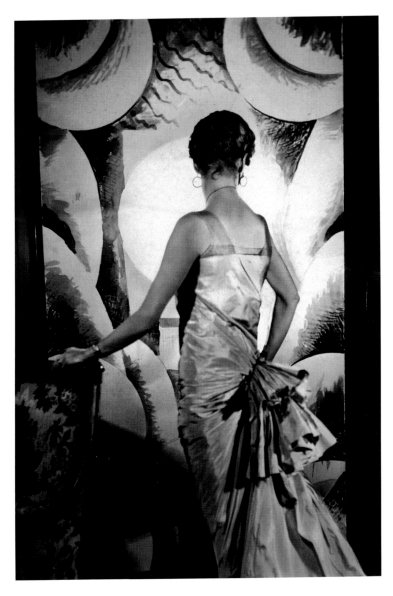

PLATE 22 Margot Asquith, Countess of Oxford, 1927

PLATE 23 Iris Tree (Mrs Curtis Moffat), 1928

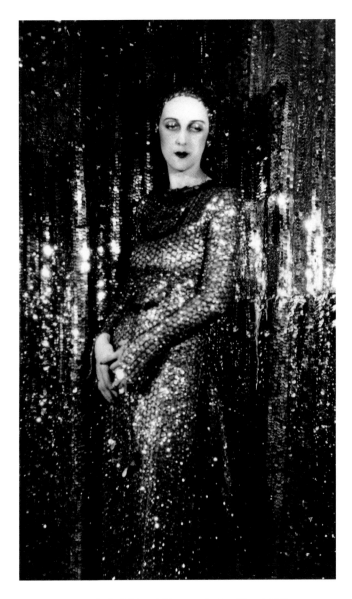

PLATE 24 Paula Gellibrand (Marquise de Casa Maury), 1928

PLATE 25 Sylvia Sidney, Hollywood, 1932

PLATE 26 Johnny Weissmuller on the set of *Tarzan*, Hollywood, 1932

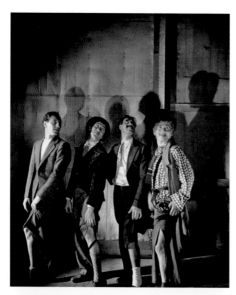

PLATE 27 The Marx Brothers, Hollywood, 1932

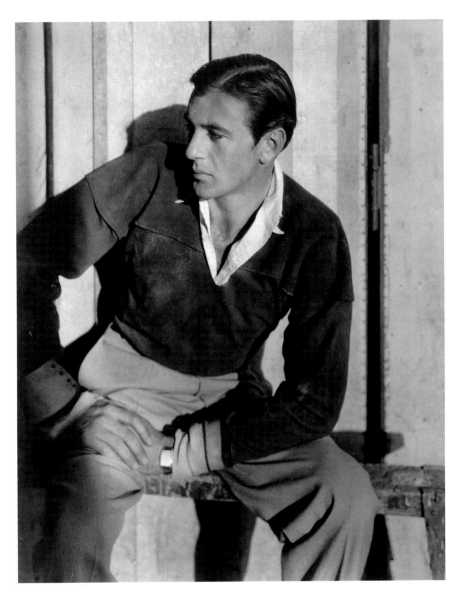

PLATE 28 Gary Cooper, 1931

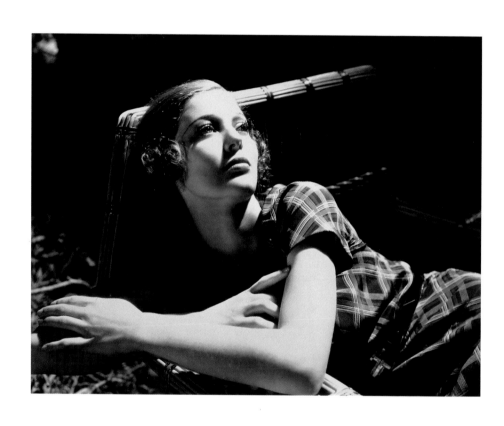

PLATE 29 Loretta Young, Hollywood, 1930s

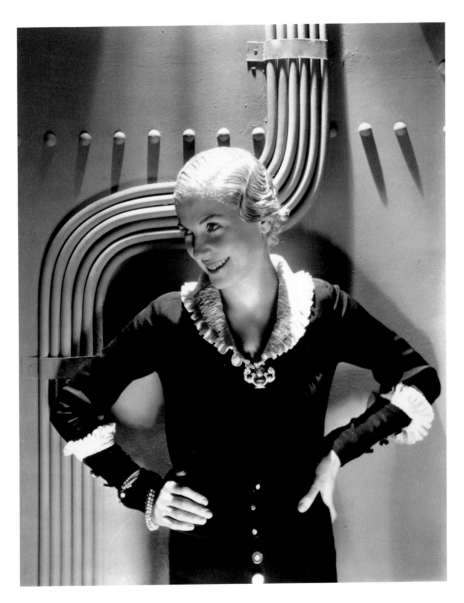

PLATE 30 Lilyan Tashman, Hollywood, 1930s

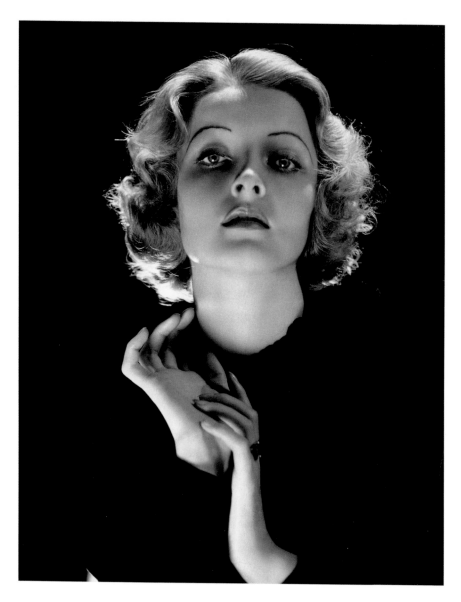

PLATE 31 Gwili André, Hollywood, 1932

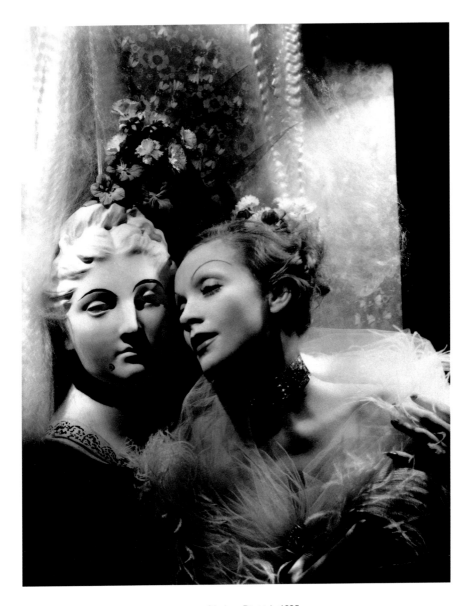

PLATE 32 Marlene Dietrich, 1935

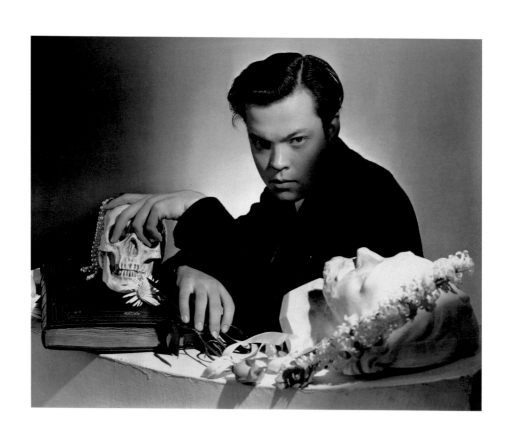

PLATE 33 Orson Welles, 1937

PLATE 34 Katharine Hepburn, 1934

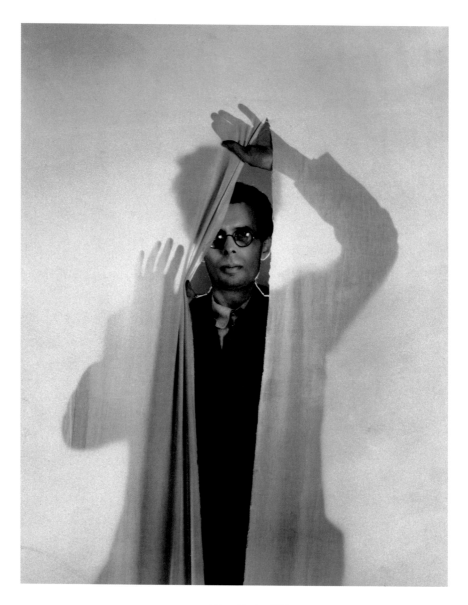

PLATE 35 Aldous Huxley, 1936

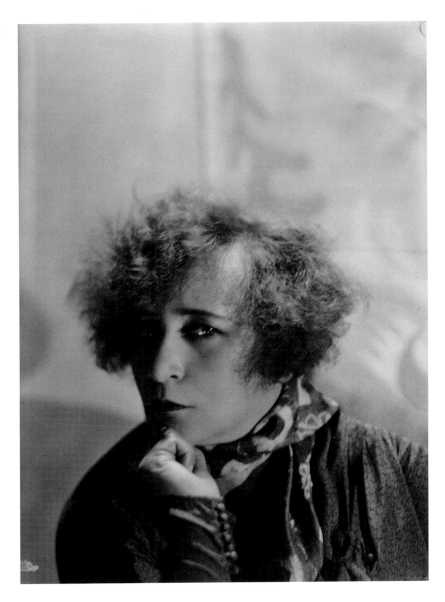

PLATE 36 Colette, Paris, 1930

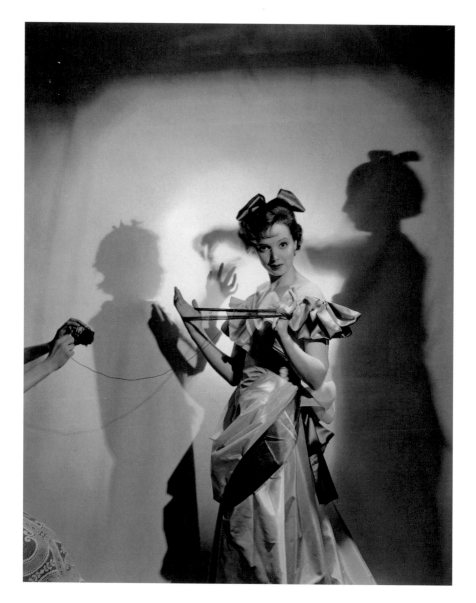

PLATE 37 Jessie Matthews, 1936

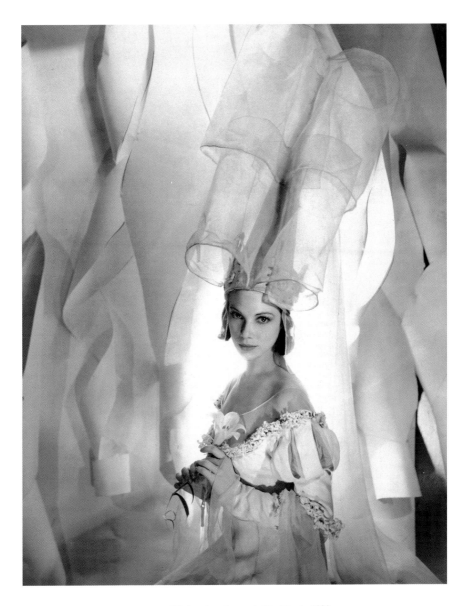

PLATE 38 Tilly Losch as the nun in *The Miracle*, 1932

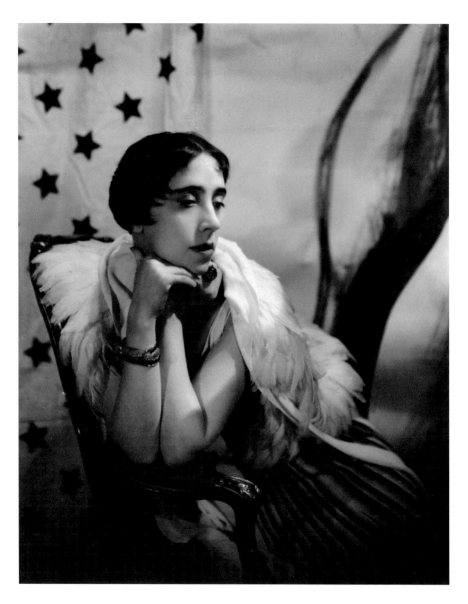

PLATE 39 Elsa Schiaparelli, 1936

PLATE 40 Coco Chanel, 1937

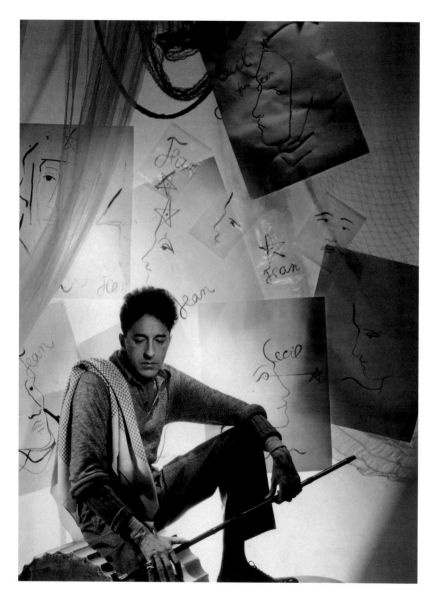

PLATE 41 Jean Cocteau, 1934

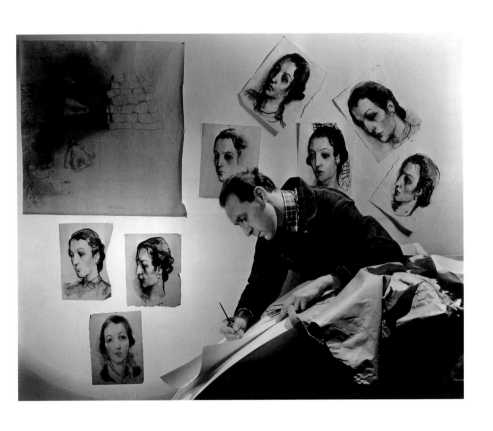

PLATE 42 Pavel Tchelitchew, 1934

PLATE 43 Christian Bérard, 1937

PLATE 44 Pablo Picasso, 1933

PLATE 45 George Platt Lynes, 1930s

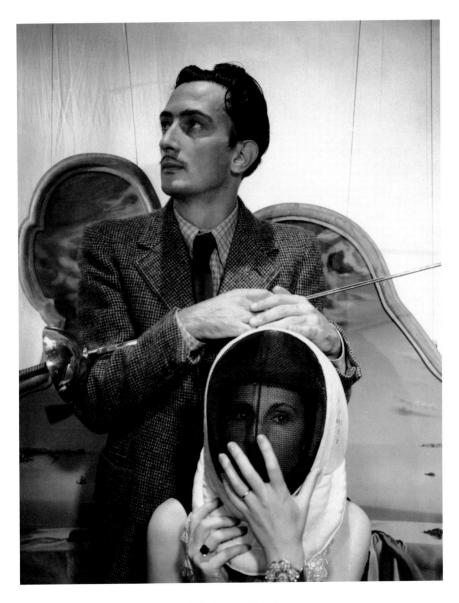

PLATE 46 Salvador and Gala Dalí, 1936

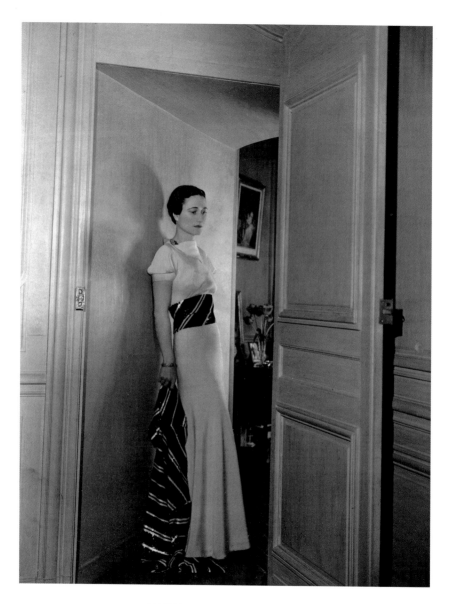

PLATE 47 Wallis Simpson in a gown by Mainbocher, 1937

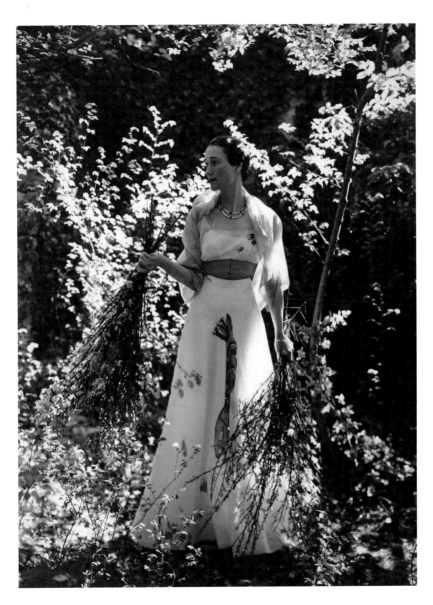

PLATE 48 Wallis Simpson in a dress by Schiaparelli, Chatêau de Candé, 1936

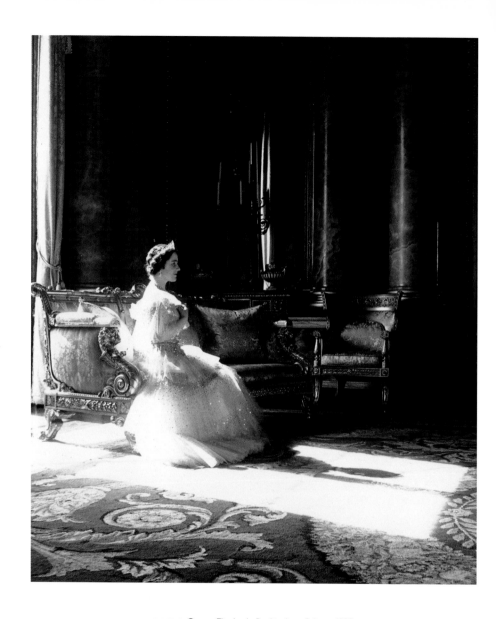

PLATE 49 Queen Elizabeth, Buckingham Palace, 1939

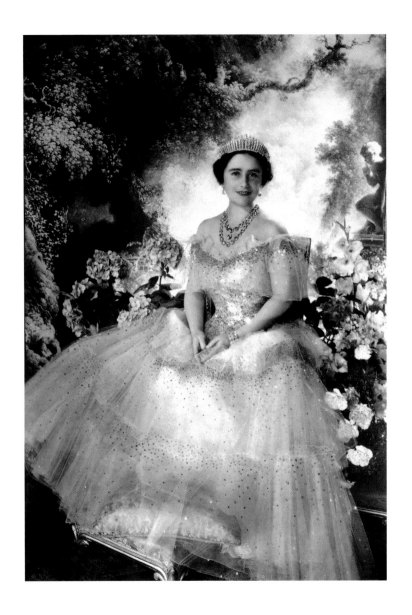

PLATE 50 Queen Elizabeth, Buckingham Palace, 1939

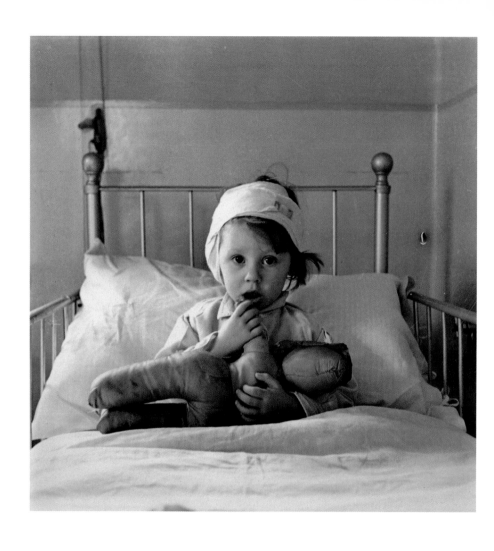

PLATE 51 Eileen Dunne in The Hospital for Sick Children, 1940

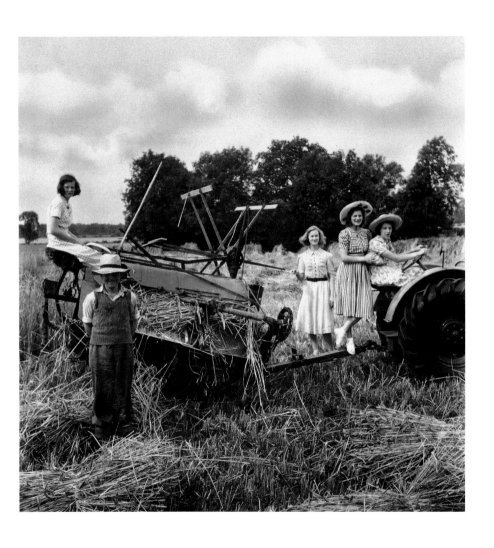

PLATE 52 Mary Churchill (*second from left*), Judy Montagu (*far right*) and friends posing as land girls, 1940

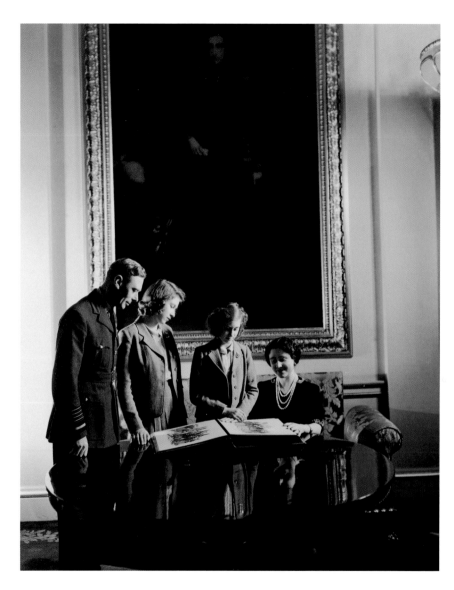

PLATE 53 The Royal Family, (*from left to right*: King George VI,
Princesses Elizabeth and Margaret, and Queen Elizabeth), 1942

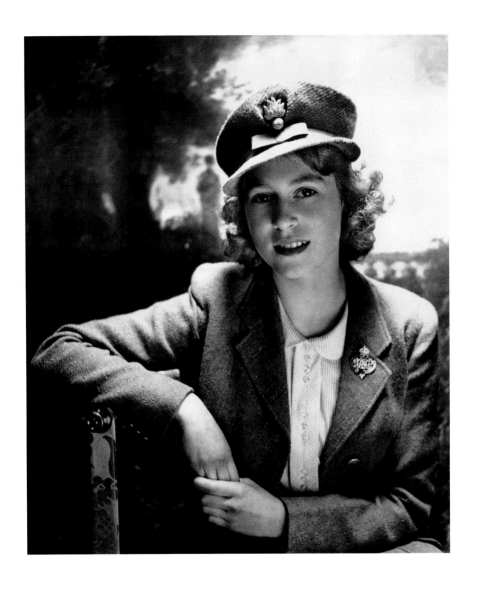

PLATE 54 Princess Elizabeth, 1942

PLATE 55 Mrs Winston Churchill, 10 Downing Street, 1940

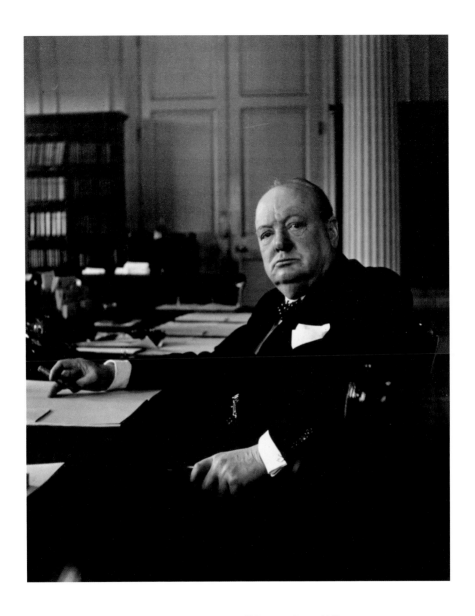

PLATE 56 Winston Churchill, 10 Downing Street, 1940

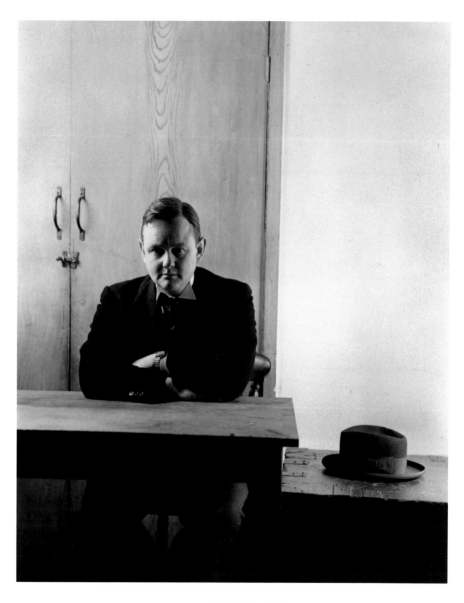

PLATE 57 Quintin Hogg, 1944

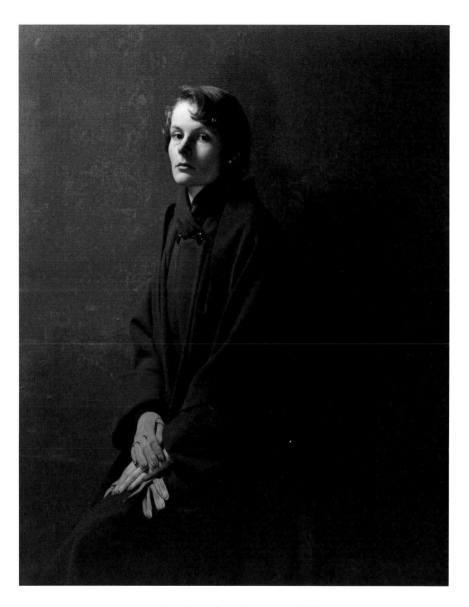

PLATE 58 Clarissa Churchill, Lady Avon, 1949

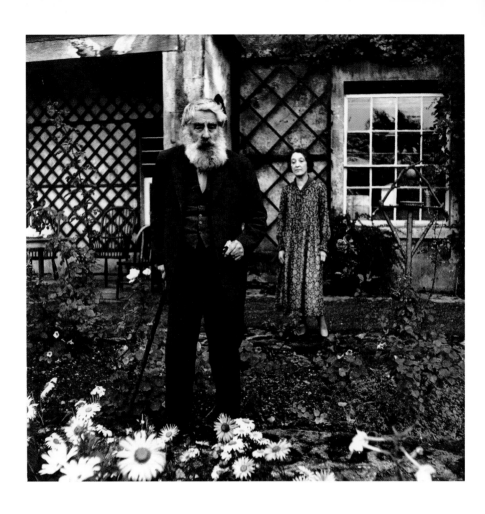

PLATE 59 Walter Sickert and his wife Therese Lessore, 1940

PLATE 60 Augustus John and Dorelia, 1960

PLATE 61 Noël Coward, 1942

PLATE 62 Vivien Leigh as Cleopatra, 1945

PLATE 63 Cecil Day-Lewis, 1942

PLATE 64 Benjamin Britten and Peter Pears, 1942

PLATE 65 Air Vice-Marshal Sir Arthur Coningham, 1942

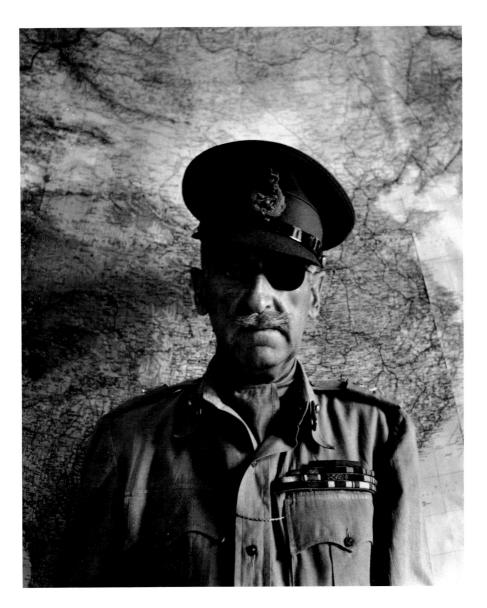

PLATE 66 Lieutenant-General Adrian Carton de Wiart, 1943

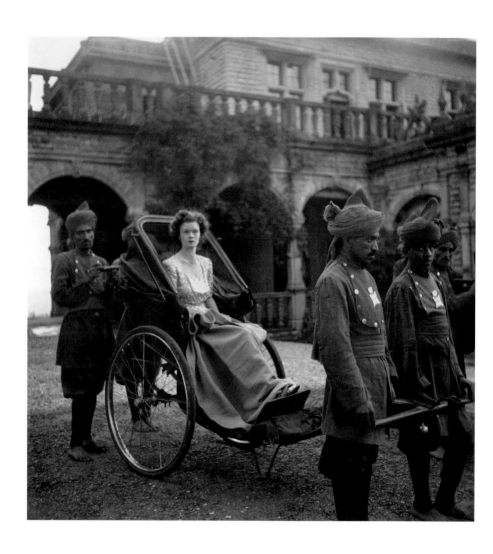

PLATE 67 Felicity Wavell, Simla, 1944

PLATE 68 Field Marshall Lord Wavell, 1944

PLATE 69 Lady Wavell, 1944

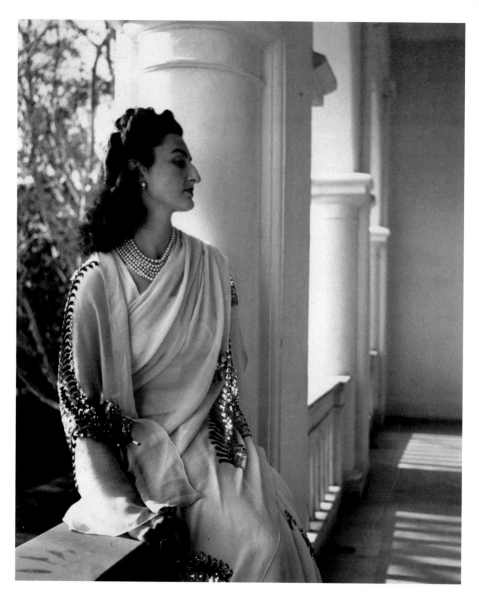

PLATE 70 Princess of Berar, 1944

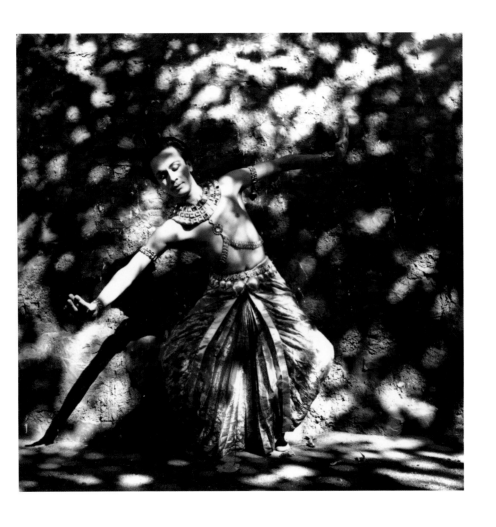

PLATE 71 Ram Gopal, 1944

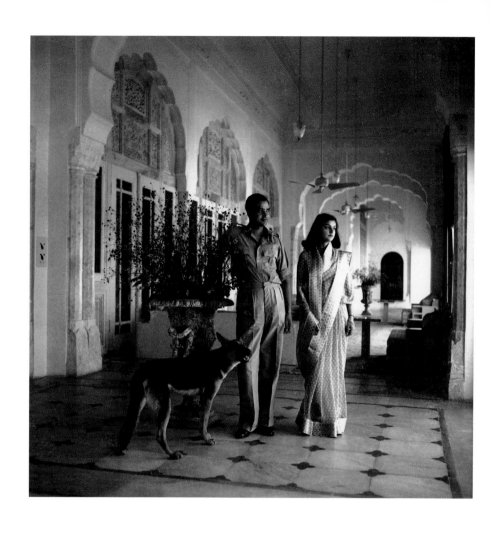

PLATE 72 Maharajah and Maharani of Jaipur, 1944

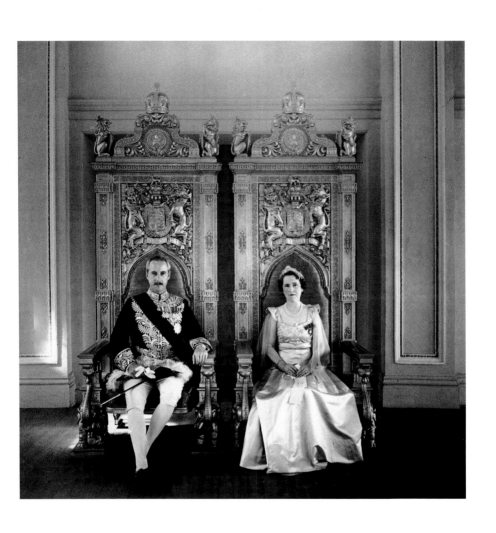

PLATE 73 Sir John Colville and Lady Colville, 1944

PLATE 74 Queen Fawziah of Persia, 1942

PLATE 75 King Feisal II of Iraq, 1942

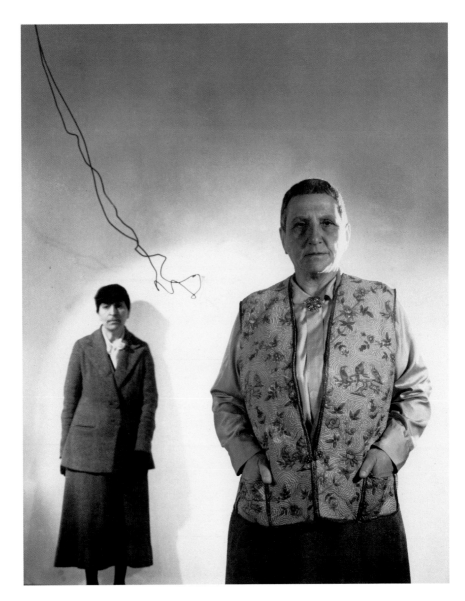

PLATE 76 Alice B. Toklas and Gertrude Stein, 1936

PLATE 77 Marianne Moore and her mother, 1946

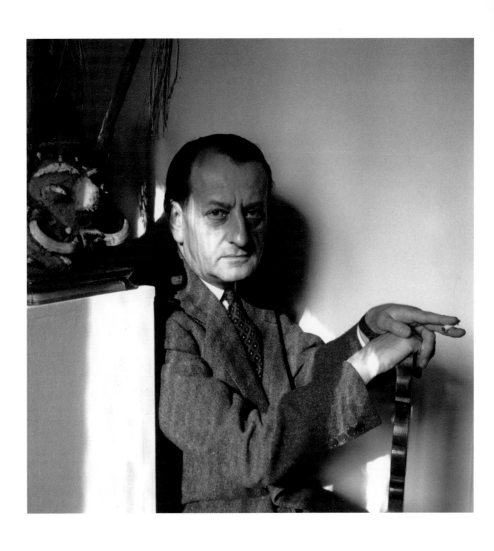

PLATE 78 André Malraux, 1946

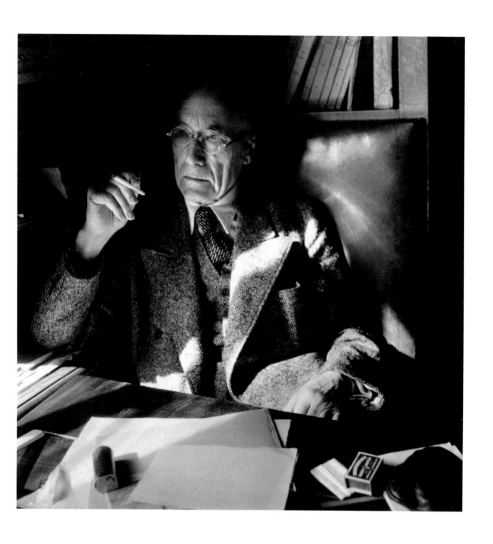

PLATE 79 André Gide, 1945

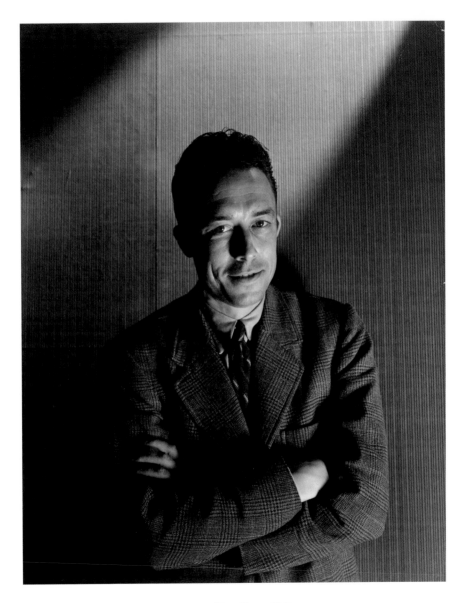

PLATE 80 Albert Camus, 1946

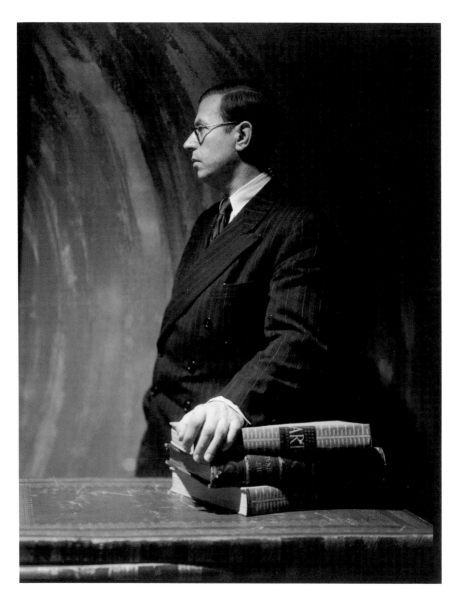

PLATE 81 Jean-Paul Sartre, 1946

PLATE 82 Greta Garbo, 1946

PLATE 83 Greta Garbo, 1946

PLATE 84 Yul Brynner, 1946

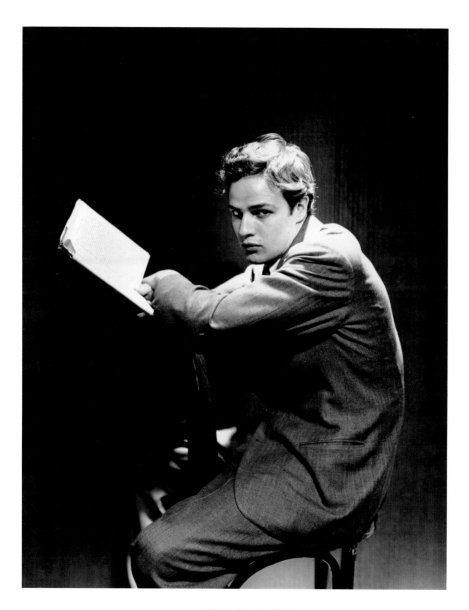

PLATE 85 Marlon Brando, 1946

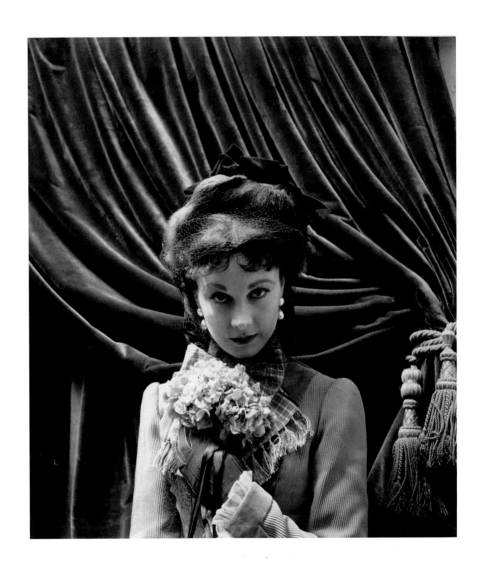

PLATE 86 Vivien Leigh as Anna Karenina, 1947

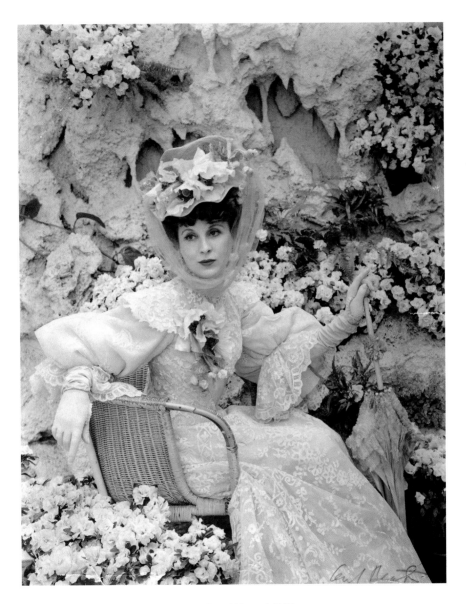

PLATE 87 Diana Wynyard, 1947

PLATE 88 Francis Bacon, 1951

PLATE 89 Ivy Compton-Burnett, 1949

PLATE 90 (*from right:*) Truman Capote, David Herbert and Jane Bowles, Morocco, 1949

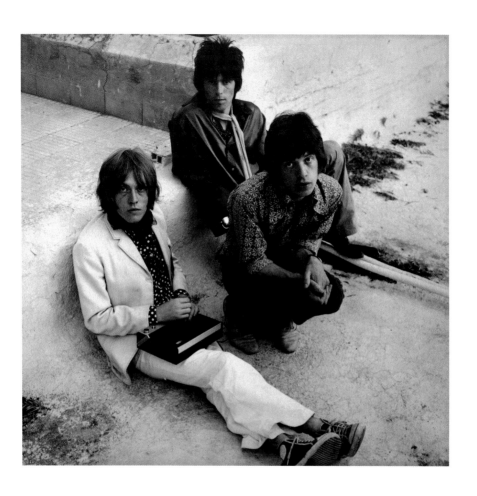

PLATE 91 The Rolling Stones (*from left to right*: Brian Jones, Keith Richards and Mick Jagger), Marrakesh, 1967

PLATE 92 James Caffrey and the Hon. Mrs Reginald Fellowes at the *Carlos De Beistegui Ball*, Venice, 1951

PLATE 93 Lady Diana Cooper dressed as Cleopatra, Venice, 1951

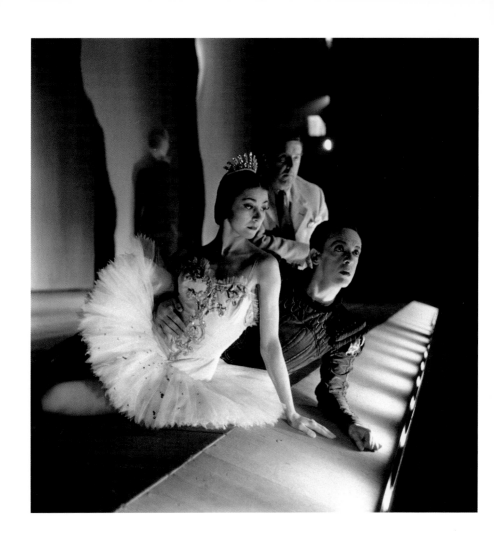

PLATE 94 Margot Fonteyn with Frederick Ashton and Robert Helpmann, 1950

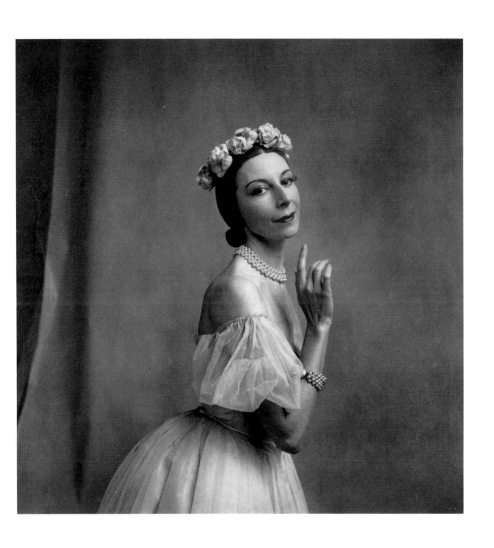

PLATE 95 Alicia Markova, 1950

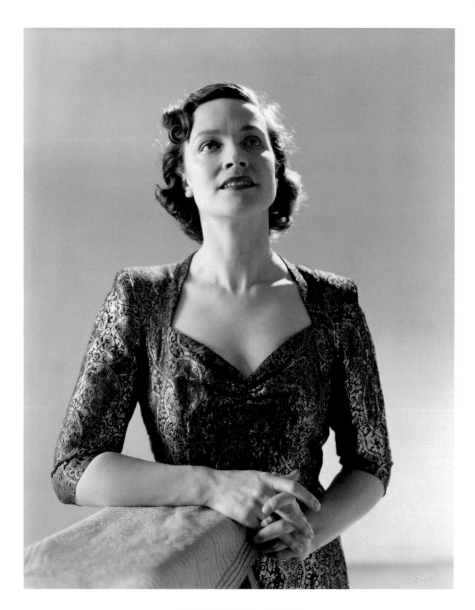

PLATE 96 Kathleen Ferrier, 1952

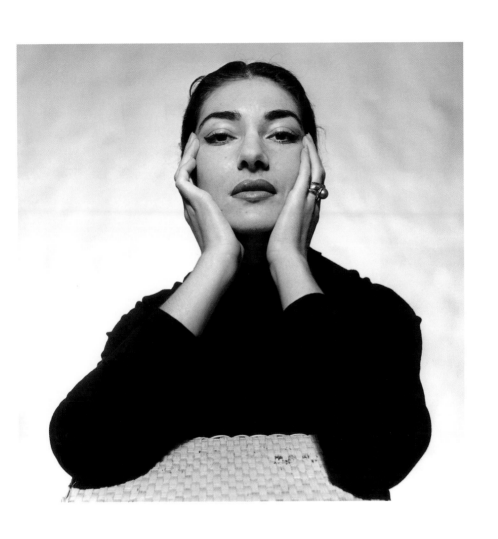

PLATE 97 Maria Callas, 1957

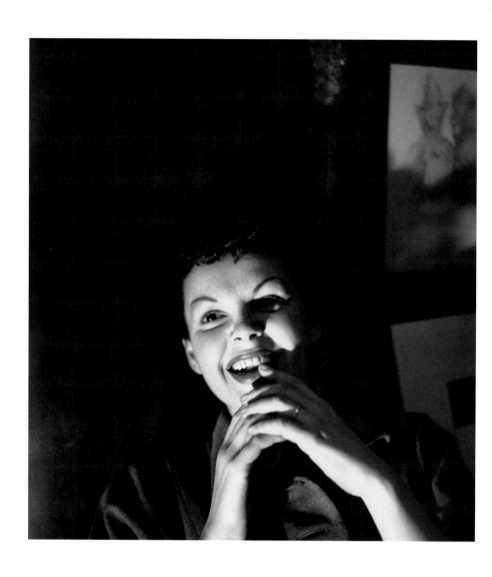

PLATE 98 Judy Garland, 1953

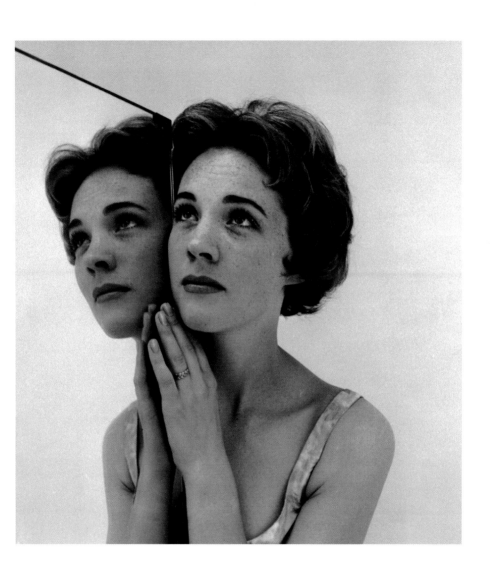

PLATE 99 Julie Andrews, 1959

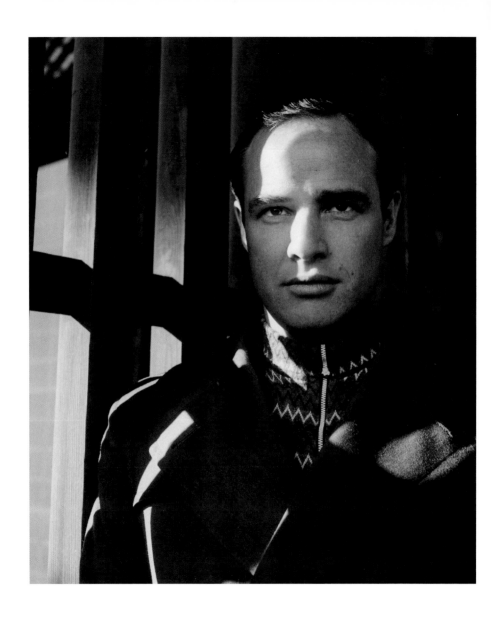

PLATE 100 Marlon Brando, 1953

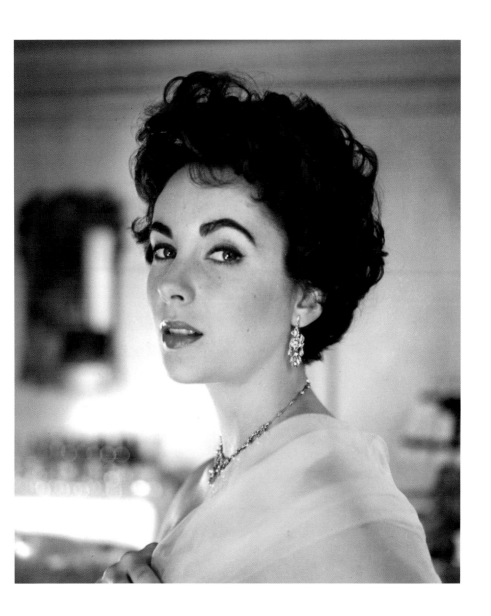

PLATE 101 Elizabeth Taylor, 1954

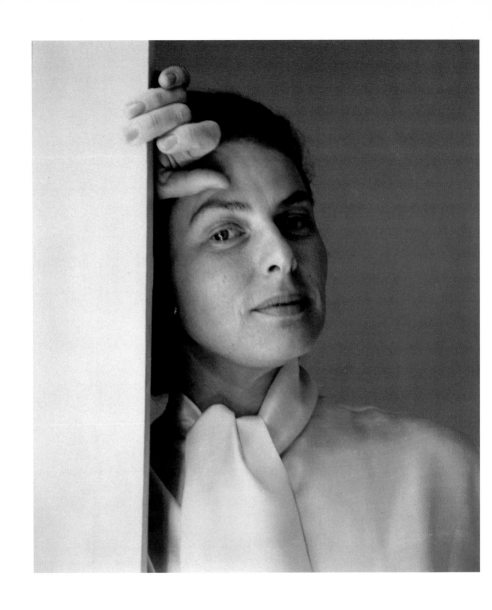

PLATE 102 Ingrid Bergman, 1958

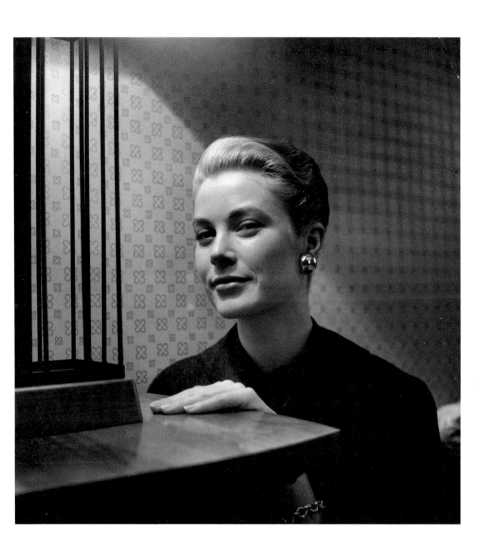

PLATE 103 Grace Kelly, 1954

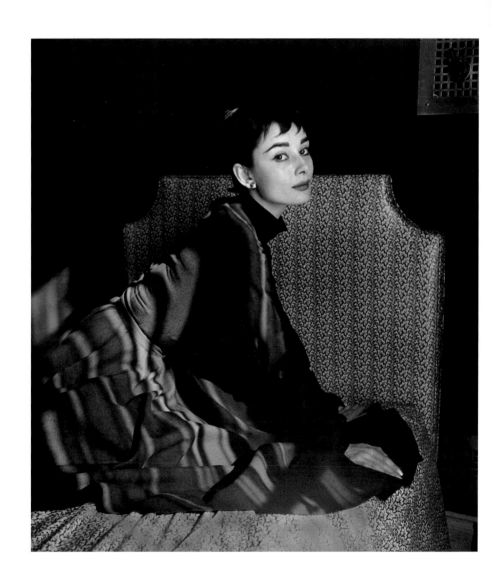

PLATE 104 Audrey Hepburn, 1954

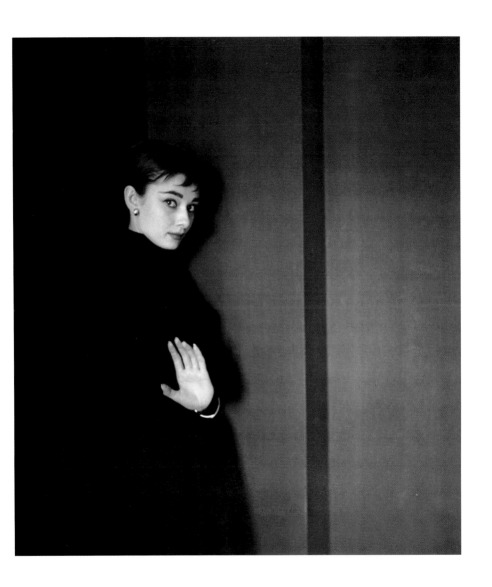

PLATE 105 Audrey Hepburn, 1954

PLATE 106 Tennessee Williams, 1950s

PLATE 107 Joan Crawford, 1956

PLATE 108 John and James Pope-Hennessy, 1955

PLATE 109 John Betjeman, 1955

PLATE 110 Carson McCullers, 1956

PLATE 111 Mary McCarthy, 1955

PLATE 112 Bernard Berenson and Nicky Mariano, I Tatti, 1955

PLATE 113 Mr and Mrs Richard Avedon, Reddish House, 1955

PLATE 114 Lucian Freud and Lady Caroline Blackwood, 1956

PLATE 115 Contact sheet of Lucian Freud, 1956

PLATE 116 T.S. Eliot, 1956

PLATE 117 Harold Pinter, 1962

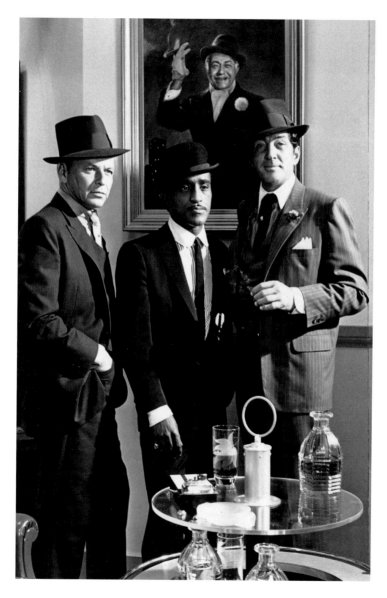

PLATE 118 Frank Sinatra, Sammy Davis Jr and Dean Martin (in front of a portrait of Edward G. Robinson), 1964

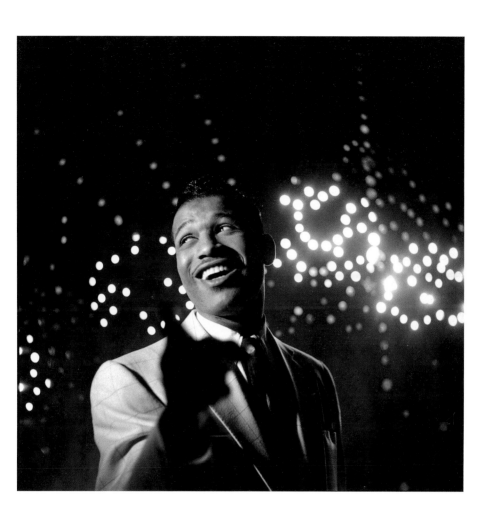

PLATE 119 Sugar Ray Robinson, 1953

PLATE 120 Saul Steinberg, 1956

PLATE 121 Charles Addams, New York, 1956

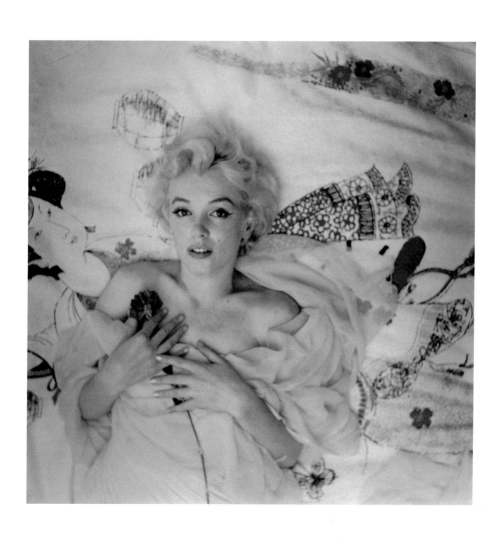

PLATE 122 Marilyn Monroe, 1956

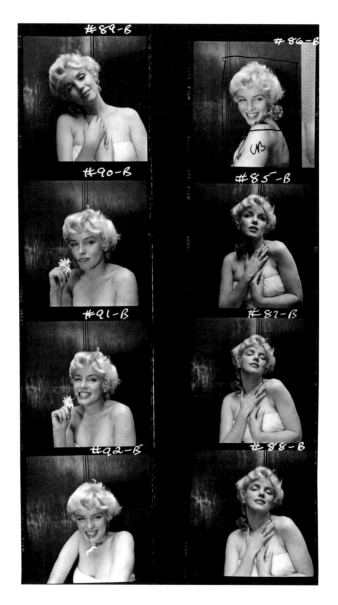

PLATE 123 Contact sheet of Marilyn Monroe, 1956

PLATE 124 Leslie Caron as Gigi, 1957

PLATE 125 Leslie Caron as Gigi, 1957

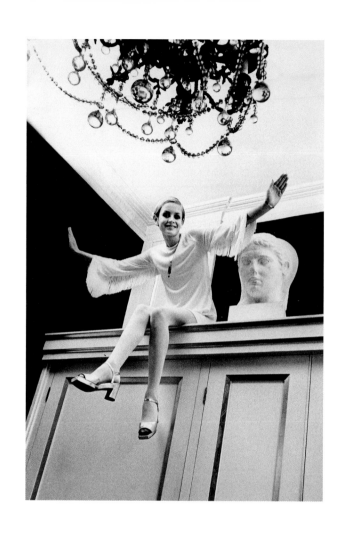

PLATE 126 Twiggy, 8 Pelham Place, 1967

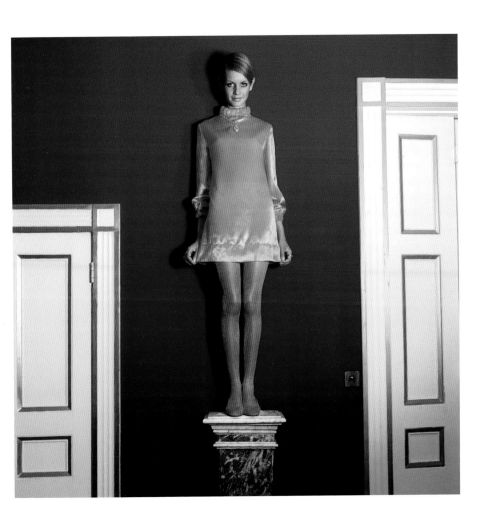

PLATE 127 Twiggy, 1967

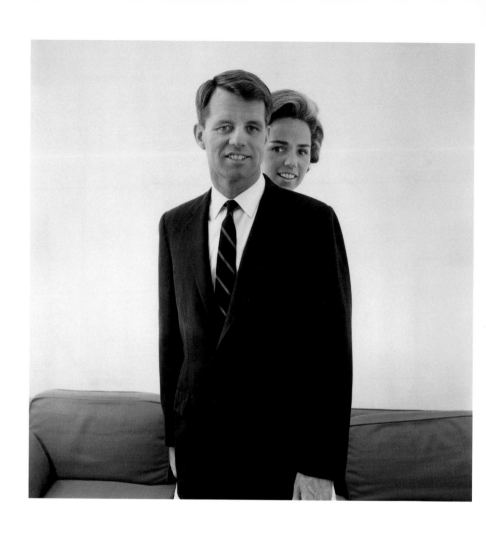

PLATE 128 Mr and Mrs Robert Kennedy, 1961

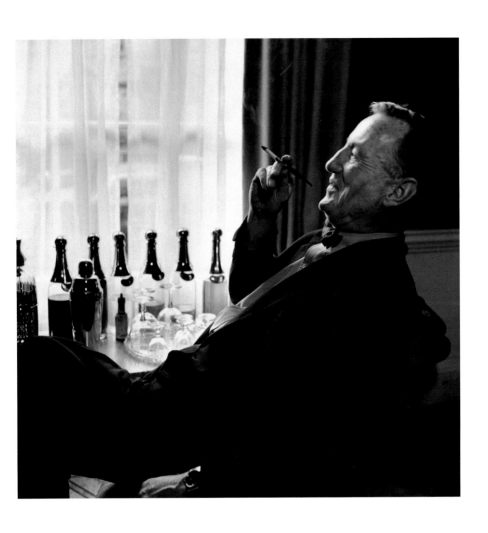

PLATE 129 Ian Fleming, 1962

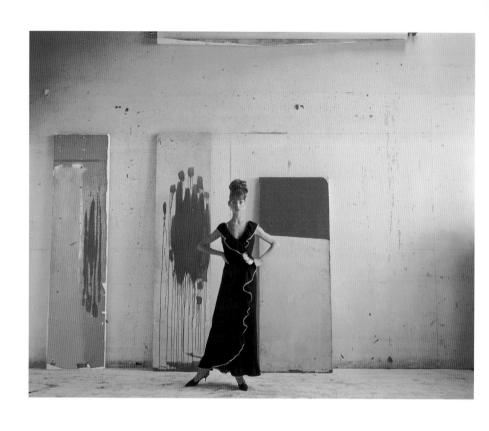

PLATE 130 Jean Shrimpton, 1964

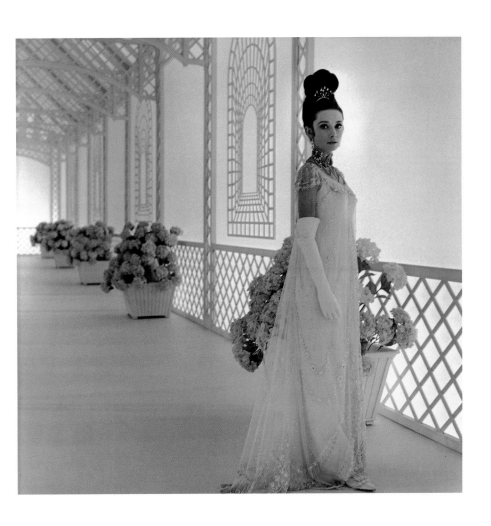

PLATE 131 Audrey Hepburn in *My Fair Lady*, Hollywood, 1963

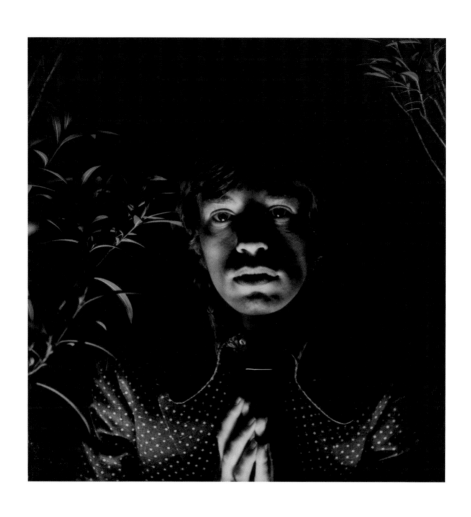

PLATE 132 Mick Jagger, Marrakesh, 1967

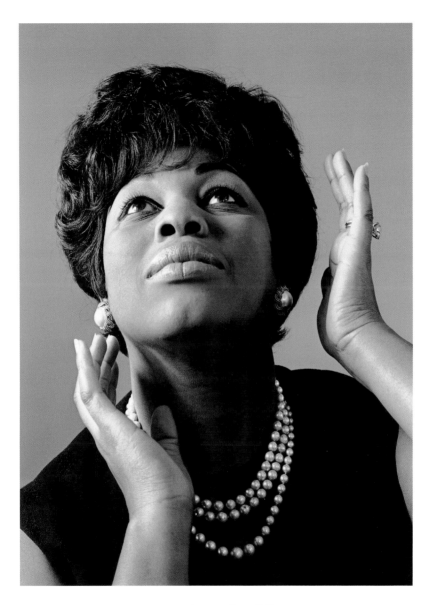

PLATE 133 Leontyne Price, 1968

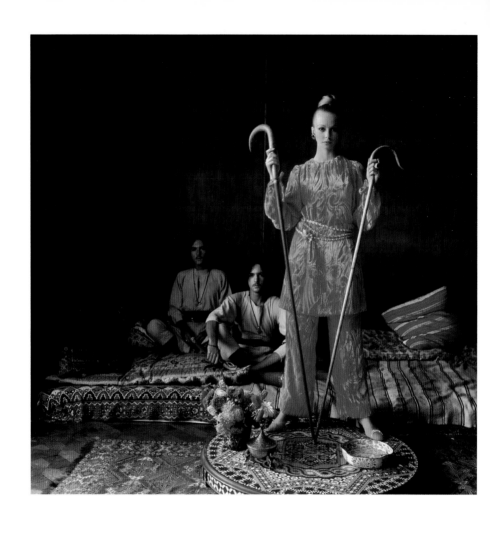

PLATE 134 Maudie James and the Myers Twins, 1968

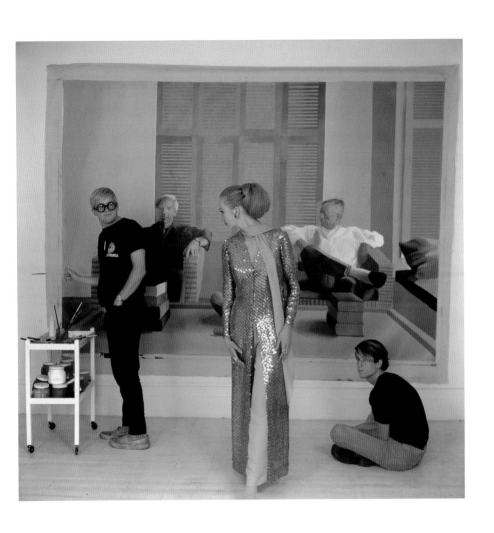

PLATE 135 David Hockney, Maudie James and Peter Schlesinger, 1968

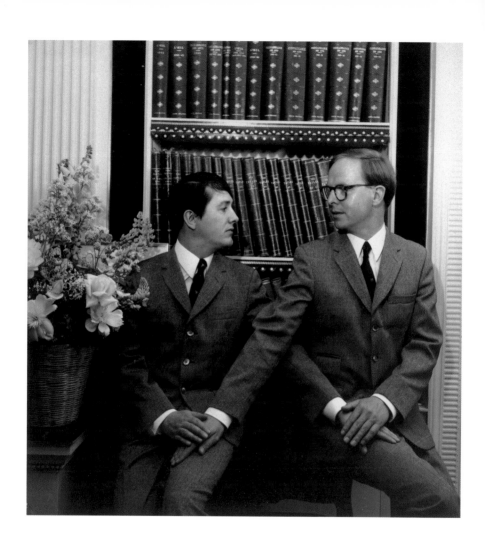

PLATE 136 Gilbert and George, 1968

PLATE 137 Gervase Griffiths and Patrick Procktor, Reddish House, 1968

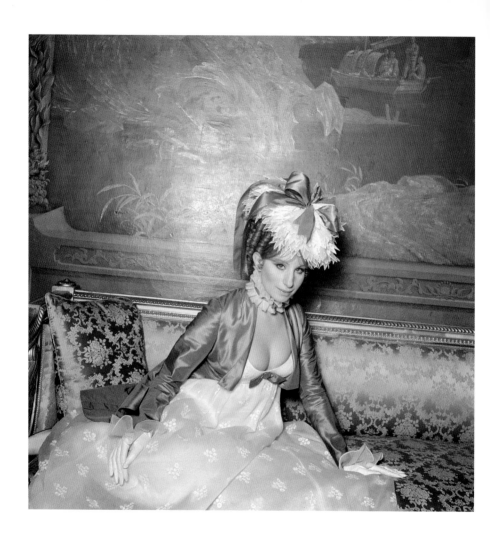

PLATE 138 Barbra Streisand on the set of *On a Clear Day You Can See Forever*, Brighton Pavilion, 1969

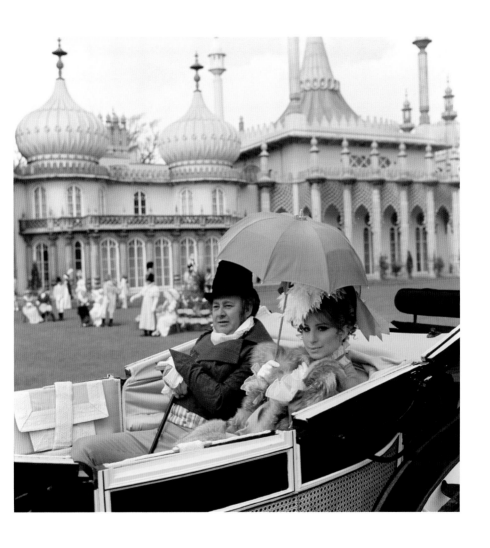

PLATE 139 Barbra Streisand, on the set of *On a Clear Day You Can See Forever*, with Roy Kinnear
as the Prince Regent, Brighton Pavilion, 1969

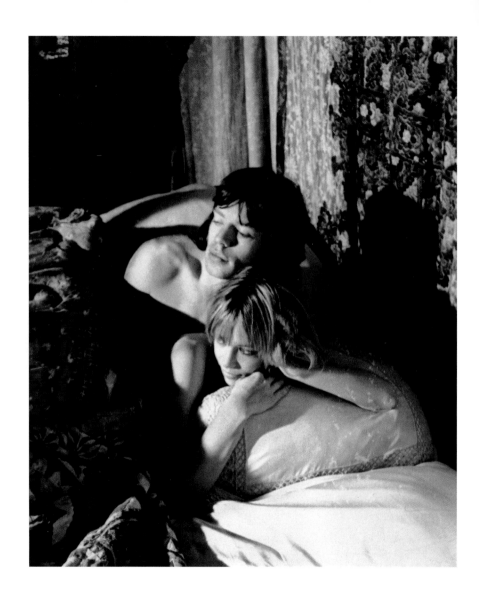

PLATE 140 Mick Jagger and Anita Pallenberg on the set of *Performance*, 1968

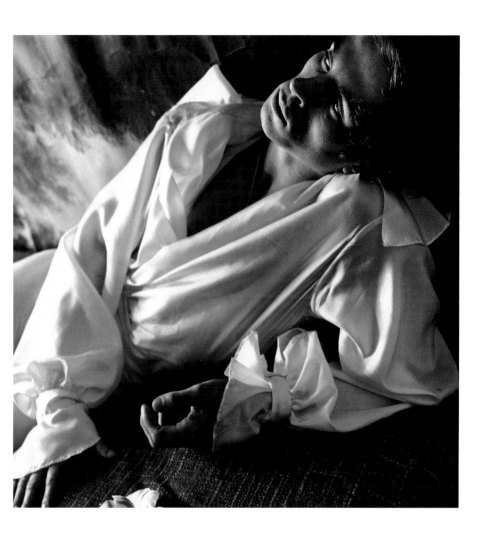

PLATE 141 Rudolf Nureyev, 1963

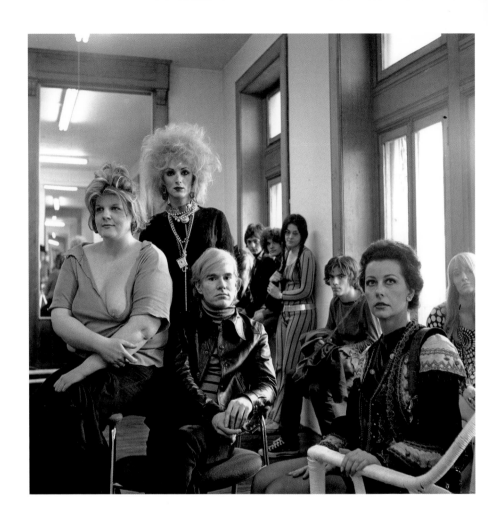

PLATE 142 (*from left to right:*) Brigid Polk, Candy Darling, Andy Warhol and Ultra Violet, 1969

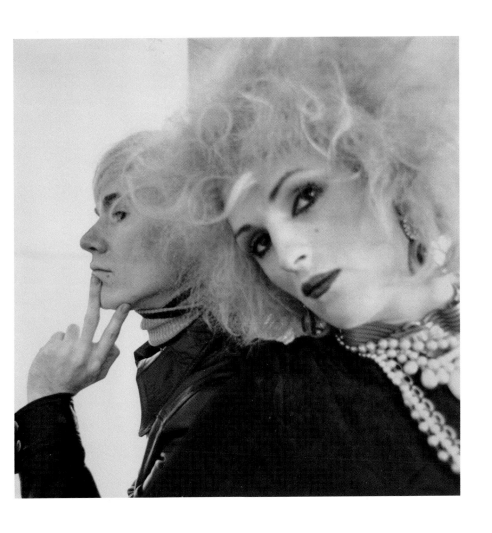

PLATE 143 Andy Warhol and Candy Darling, 1969

PLATE 144 André Courrèges, Paris, 1968

PLATE 145 Tom Wolfe, 1969

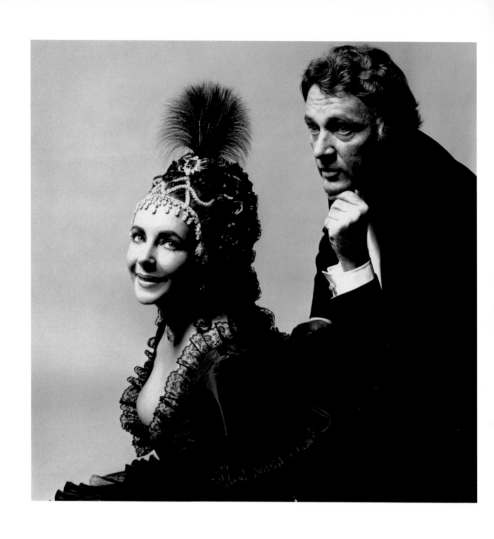

PLATE 146 Elizabeth Taylor and Richard Burton at the *Proust Ball*, 1971

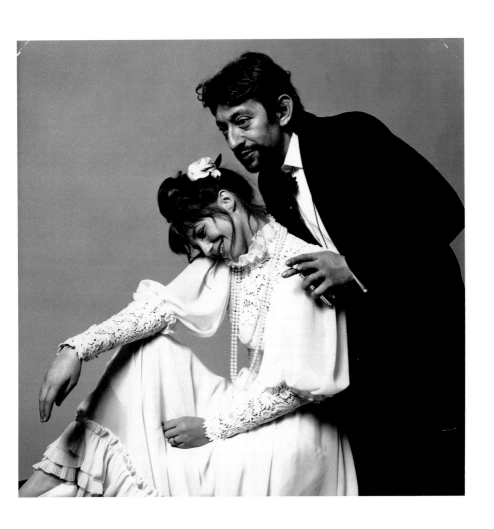

PLATE 147 Jane Birkin and Serge Gainsbourg at the *Proust Ball*, 1971

PLATE 148 Charlotte Rampling in *Zinotchka*, 1973

PLATE 149 Bianca Jagger, Reddish House, 1978

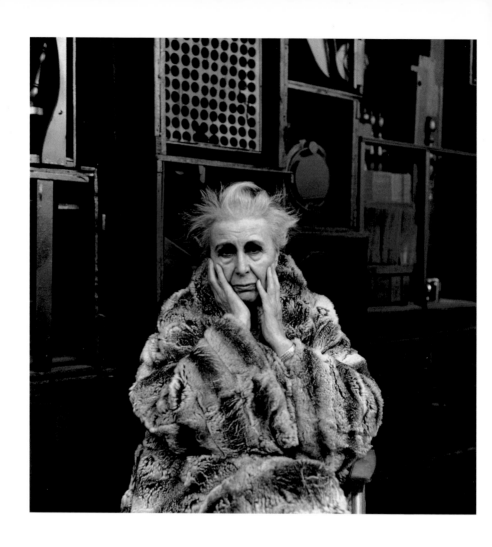

PLATE 150 Louise Nevelson, New York, 1978

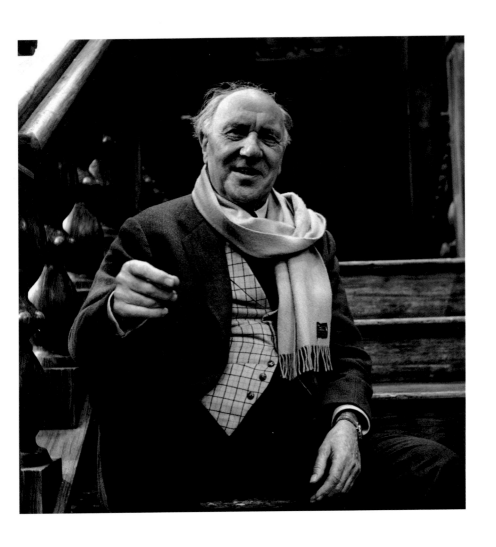

PLATE 151 Ralph Richardson, National Theatre, London, 1979

Beaton in Brilliantia

Peter Conrad

ARTISTS lead charmed lives. Adulthood for them indefinitely and luxuriously prolongs infancy; the work they do is play. But their games are serious matters, enabling them to rearrange the world and alter its rules. If they are honest or brave enough, they acknowledge that reality cannot be so easily vanquished, and watch as it ravages the fictions they have fabricated.

Cecil Beaton was many artists in one. He took photographs, wondering as he did so whether this 'technical process' qualified as 'an expression of the creative spirit', but he also wrote, painted, designed and acted; his houses were artworks, and so were his gardens. He collected art and collected people who possessed aesthetic distinction, choosing weekend guests – as he admitted – for 'their photogenic qualities'. A young man with whom he cohabited in 1965 was appraised as 'an adornment to [his] house', his 'most prized possession'. The relationship faltered when the object of his adoration behaved unbeautifully, discarding food scraps on the floor.

Beaton himself was a living work of art, an exquisitely dandified product of his own imagination. Aestheticism was his credo, and in 1928 he set the agenda of his life by declaring 'beauty' to be 'the most important word in the dictionary'. His quaint private lexicography equated it with art, and also with morality: it was a synonym, he said, for 'endeavour, perfection, the right, the true, the good'. Design for Beaton had a utopian mission, and the latest Paris clothes were aids to instruction, instruments of reform. Complimenting Elsa Schiaparelli, he said that he 'admired enormously the dresses by which she was teaching the world her especial idea of aesthetics'.

Beaton defined himself as 'a manipulator of the camera', though what he manipulated was the reality at which he pointed the camera. His photographs documented his achievement in persuading actuality to mimic artifice. He resolved his worry about whether photography qualified as art by coaxing his sitters to assume a place in the history of painting. On a

single page in his *Photobiography* (1951), he portrayed Edith Sitwell as a Gothic tomb carving (plate 8), then as a character in a Zoffany conversation piece, enthroned in her four-poster bed with a maid in attendance. He saw Queen Elizabeth, later the Queen Mother, through the eyes of the Victorian court painter Winterhalter (plate 50). Marlene Dietrich, when skeletal, reminded him of a Dürer figure. After she put on weight, she seemed like a Cranach woman, her face resembling veal. Photographing Mick Jagger in Morocco, he noted that 'I made him look like a Tarzan by Piero di Cosimo' (plate 33). On another occasion, Jagger impersonated a Piero della Francesca martyr.

Photographers like to think of themselves as alchemists, magically transforming base matter into gold. Beaton guarded his own mystery by professing not to know how he managed the feat. During his first experiments in a makeshift darkroom in his parents' house, he said 'I am ashamed of being so inept at the technical side of the game.' The amateurism was an affectation; it is revealing, however, that he called his vocation a 'game'. But just what was the game he spent his life playing? Evelyn Waugh, who bullied him at school, scoffed in 1961 that he was 'consumed by worldly ambition, not for power nor for creation' but simply for social recognition. Waugh missed the point. The young Beaton – his languid, drawling elocution improved by the Edwardian actress Mrs Patrick Campbell, his deportment and costume discreetly adjusted by Noël Coward, who advised against colour-coordinating socks, tie and pocket handkerchief – was his own autonomous creation. This creative feat conferred power, because it removed him from the drab and worthy middle class into which he was born.

Photography, as Beaton conceded, was at first incidental, useful mainly because it helped him to climb socially. But the world that he ambitiously set out to conquer also capitulated to his creative fantasy: he redesigned it to suit himself. He treated bomb damage as surrealistic decor, and thought that a London arcade, swamped after a Luftwaffe raid, was positively Venetian. He could only conceive of nature by annexing it to what he called 'the great indoors'. The desert around Tobruk, which he saw during a wartime expedition in 1942, struck him as drearily and outmodedly beige: its wan tone 'might have been "fixed" by an interior decorator in 1928', when beige was briefly popular. Accidents, those momentary disruptions that other photographers prized, were not permitted. A twisted, intrusive electric cable made itself at home in his portrait of Gertrude Stein and Alice B. Toklas by posing as an artwork: Stein declared that it resembled one of Alexander Calder's mobiles (plate 76).

As a boy, Beaton had a toy theatre with stick figures that he moved about using metal prongs. In 1939 he strung up some living mannequins in a life-size puppet theatre, where they modelled gauzy frocks. He admired the 'marionette quality' of Diaghilev's ballerina Lydia Lopokova, whom he likened to an inorganic wax doll; later, photographing Twiggy, he called her 'a punctured marionette', worn down and torn apart by the managers who tugged the strings and jerked her emaciated limbs. In *My Fair Lady*, Mrs Higgins upbraids her son and his friend Pickering for their treatment of Eliza: 'You're a pretty pair of babies, playing with your live doll!' The remark might have been addressed to Beaton, who designed both the stage production of the musical in 1955 and George Cukor's film eight years later. By the end of his life, the models he prodded and posed within the proscenium of the photographic frame ranged from his own family to the royal family; they were his characters, and he was their author. Having been photographed, they were glued into the albums or scrapbooks that Beaton assembled throughout his life, which were his sketches of a new solar system. Here he reigned, controlling the patterned, ceremonious motions of the starry bodies. He was, as his *Vogue* colleague Erwin Blumenfeld pronounced him, the 'crown prince of Brilliantia', and he viewed the people he admired as if they were asteroids. In 1929, Beaton photographed his sister pausing in her transit across the sky to shed a blitz of spangles (plate 3). In 1950 in New York he designed the ballet *Les Illuminations*, choreographed by Frederick Ashton to Benjamin Britten's settings of Rimbaud's ecstatic, abandoned poems. The singer in the orchestra pit described stretching ropes between steeples and linking the stars with golden chains, and then in a slithering, swooning vocal cadenza cried 'Je danse!' At that moment on stage, the dancer hurled confetti into the air and let brightness rain down on him in a spangled shower. The artist had invented his own milky way. This galactic orgasm incidentally mimed the making of these constellations that Beaton arranged in his albums.

One lyric in *Les Illuminations* was given the English title 'Being Beauteous' by Rimbaud. It depicts a beauteous being whose presence excites a carnal frenzy, and it defines the state of being beauteous, which was the sole occupation of Beaton's swan-like narcissists. As Oscar Wilde said, to fall in love with yourself is the beginning of a life-long affair (and there is no risk of being betrayed, or feeling your passion cool). In 1927, Maurice Beck and Helen MacGregor photographed Beaton with his friend Stephen Tennant, a foppish patrician. Nestled together side by side, they wear the same striped sweaters, have the same waved and shining hair, and hold their profiles at the same angle, while a mirror that cuts them off at the

waist repeats the flattering miracle of duplication (fig.2). The loved one must be your mirror-image, not your opposite. Beaton's expertise in self-fashioning prompted his concern with fashion. 'In my suit of plus fours', he wrote in his diary during the 1920s, 'I felt like a new person'. Clothes for Beaton did not so much make the man as supersede him. They were – as Ophelia says in the speech from which Beaton took the title of his book *The Glass of Fashion*, published in 1954 – the 'mould of form'. They possessed personality on their own; the wearer was expendable. At Haworth parsonage in 1957 Beaton photographed a dress that once belonged to Charlotte Brontë, starchily propped up in a glass case. It is being worn by a stick figure: the sleeves, primly folded across the waist, have no arms to fill them out, and there is a stump where the head ought to be. The dress is the social uniform that Charlotte had to squeeze into, from which she has now been released. Beaton's plus fours renovated him; Charlotte's dress, with its tight waist, imprisoned her.

Having invented himself with the help of his wardrobe, Beaton then showed his subjects how to reinvent themselves. According to his account of the Coronation in 1953, monarchy attached to the costumes and regalia – especially the Queen's magnificently Byzantine gown of 'stiff bell-shaped brocade' – rather than inhering in the young woman who was dressed and undressed by the officiating clergy during the ceremony. She became a sovereign, Beaton noted, at the moment when 'the Imperial Crown, containing the Black Prince's ruby and four drop-shaped pearls said to have been the earrings of Queen Elizabeth I', was lowered into place on her tightly curled hair.

In New York he studied a beauty parlour that specialised in 'the shelling of the face', and on his first trip to Hollywood, he noticed shops advertising 'face aesthetics' and even 'face exchange'. Photography performed the same service without abrasive scrubbing or surgery. With what Beaton called its 'silvery magic', it bestowed 'a glorious halo' on the people it portrayed. Even the royal family benefited from the mystique he dispensed with the aid of diffused light and portable scenic backdrops copied from a Fragonard fête-champêtre. The aesthetic wraiths in his photographs – 'dream-shapes' as Peter Quennell called them in 1941, all descendants of the 'divine creature' Lily Elsie, the operetta singer whose image on a postcard, glimpsed amongst the mail on his mother's bed, had been Beaton's first infatuation – required an ideal environment in which to live. They needed bowers or boudoirs, like the neoclassical chamber occupied by the women in Charles James dresses whom he photographed in 1948; the

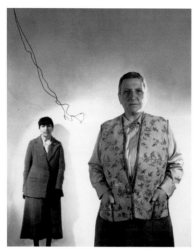

Alice B. Toklas and Gertrude Stein, 1936
PLATE 76

light is artificial, and mirrors are provided but not windows, because the characters must be protected from bleak, bruising reality.

Throughout his career, Beaton had to construct a set before he could take a photograph. At first, when his only subjects were his sisters, he dragged screens and drawing-room furniture out into the garden; later, during his winters in New York, he raided the raffish antique shops on Third Avenue for props to be used in his improvised studios. He lived in just such a set, decorating his first country house in Wiltshire with 'made-over junk' from a London street market in preparation for 'weekends of charades and folly'. When photographing at his house in Kensington, he often posed people inside the spindly metal frame of his bed: odd though this looked when the subject was an elephantine worthy like Lord Goodman, Beaton still felt he had to provide a protective bunker. In the films on which he worked, this shaky domestic bricolage could afford to be more solid. His designs for Vincente Minnelli's *Gigi* in 1957 housed the characters of Colette's story in plush Art Nouveau forests. Maurice Chevalier, as an ageing roué, inhabits a voluptuous den where ornamental peacocks flaunt jewelled tails, veiled vestal forms wear lampshades for hats, and serpentine tendrils slither towards the bed. Hermione Gingold, as Gigi's grandmother, presides in a velvety uterine cave whose shades are fleshly pink and blood red. The furnishings, in Beaton's world, have ulterior motives.

In his toy theatre, Beaton made sure that he always had the main role, even if he remained offstage. He saw photography as a performing art, and when he finally made his Broadway debut – as a malevolent gossip in a 1946 production of Oscar Wilde's *Lady Windermere's Fan* – he declared that he had served his apprenticeship as an actor in his photographic studio: it was there that he had learned about 'timing, spontaneity and projection of personality'. As an actor, he acknowledged his own nullity, which is what allowed him to be so malleable. In a 1927 self-portrait, his face proliferates so that the same sideways glance looks furtive or frightened or startlingly confidential (fig.1). He allowed other photographers to add their own fantastications. In Blumenfeld's portrait he lurks behind a shadowed profile; for Irving Penn he impersonates the bowler-hatted

Magritte; for Bert Longworth he stares into a Hollywood fun-house mirror that gives him a conical head, and for Liliane de Rothschild, who organised a Proust ball in 1971, he dresses as the photographer Nadar, a venerable and whiskered grandee. In Paul Tanqueray's portrait, Beaton has photographs of himself pinned to his jacket, while other self-images spill from his open hands . These show Beaton frowning, grinning, smirking, sniggering behind his hand or using it to block an importunate camera; the face from which these flickery, episodic, animated faces have peeled off is a cold, beakily supercilious blank from which all lines and evidence of human vulnerability have been erased.

You can never have too many dissimulating layers. The self-fashioner wears a succession of false faces; these facades, like clothes, exist to conceal the truth. Faces, as Prufrock put it in T.S. Eliot's poem, have to be prepared. Eliot himself initially refused to be photographed because he had Prufrockian scruples. He could not decide on a suitable collar, he told Beaton: 'a soft one would look untidy and Bohemian, and yet he could not bring himself to be perpetuated in a starched one'. Beaton's own facial preparations, when he made himself ready to meet other faces, were exacting. In 1927, before leaving for a weekend as Stephen Tennant's guest at Wilsford, Beaton went to Selfridges to have his skin tightened beneath a mask of clay. A male masseur gave his face a pummelling, 'almost like a rape'. Beaton relished the assault, and responded by giggling when the ticklish zones around his chin and neck were fingered.

Joking about the mirrors he used as props during photographic sessions at school, Beaton said 'I would become acutely embarrassed if ever caught in the act of self-photography.' The comment, typically impish, hints at self-abuse. In fact he avoided embarrassment because all his photographs were contributions to a long, elaborate, contradictory but consistent self-portrait. His subjects belonged to an extended family, an extension of the household in which he grew up. Women were versions of his adored mother, and she was herself a manifestation of the most immaculate matriarch of all: an early photograph he fondly recalled was 'that perfect Madonna one of Mama', and later additions to the iconography include his friend Lady Diana Cooper, who played the Virgin in Max Reinhardt's baroque pantomime *The Miracle*, and of course the Queen Mother, a smiling *magna mater* and 'nannie to us all'. Men, often less malleable, approximated to his earnest, industrious father, who could not understand his son's aesthetic gallivanting and tried to settle him in a clerical job in a City office. Beaton chose to write a play about the family life of Gainsborough because he con-

sidered him to be 'not unlike my father' in his impatience with pretension and artiness. The male principle censoriously glowers out of his portraits of a grumpy Churchill, whose work Beaton was interrupting (plate 56), or General Carton de Wiart, whose black patch is a reminder that eyes are both weapons and targets, not organs of sensual pleasure (plate 66). Quintin Hogg's hat belongs to the uniform of the officious, disciplined life that Beaton had rejected (plate 57). In diary entries about his royal sittings, he mentioned his resentment of the Duke of Edinburgh's bullying humour: here again was the belligerent, disapproving paternal superego.

Situated between an indulgent mother and a stern father, Beaton tried to combine their qualities. Orson Welles once said that actors – never secure inside their assigned bodies, and professionally adept at altering them – belonged to a third sex. Beaton presented himself as an androgynous merger of male and female. For a New York ball he dressed up as the interior designer Lady Mendl, with thinning hair, a ratty fur, and a woebegone grimace. The critic Angus MacPhail, reviewing his transvestite performance in a Cambridge musical comedy in 1923, called him 'one of our greatest living actresses'. Beaton valued the same slippery identity in his sitters. His first published portrait was of his friend George Rylands dressed as the Duchess of Malfi for a Cambridge production of Webster's play in 1924. Beaton, who had coveted the role of the Duchess himself, made sure that the travesty was teasingly exposed: the photograph was taken outside the men's lavatory in the theatre vestibule. The same mutability entranced him in Garbo who, after trying on a male disguise in Rouben Mamoulian's film *Queen Christina* in 1933, contemplated playing Dorian Gray or St Francis of Assisi. During their long and frustrated flirtation, Garbo sometimes referred to herself as Beaton's 'boy', and when he proposed marriage she wondered if he were intending to make 'an honest man' of her. Kenneth Tynan, writing about Dietrich in Beaton's book *Persona Grata* (1953), reflected that most women had gender without sex, whereas Dietrich possessed sex without gender. Beaton almost paraphrased Tynan when he said that Mick Jagger 'is sexy, yet completely sexless. He could nearly be a eunuch.' That last sentence, which Jagger might have not appreciated, constituted his highest praise. Christopher Isherwood, introducing a volume of Beaton's hallucinatory trick photographs in 1963, praised the way in which he used superimposition to turn 'Albert Finney, that most masculine actor' into 'a wholesome, fun-loving schoolgirl'.

Beaton's men and women aspire alike to the condition of the mannequin, whose sexual ambiguity is registered, as Colette pointed out in a *Vogue*

essay, by an odd, indeterminate coinage: 'we literally call this charming girl a "little man" (manikin)'. Flexing and blending the customary roles, Beaton challenged the strict differentiation between the male regime of work and the female province of leisure and cultivation. The hands of his subjects often gave them away. He was startled by Churchill's 'feminine little hands with pointed nails and fingers', and by the stumpy, 'workmanlike' hands of Garbo, which belonged in a kitchenette. The Duchess of Windsor, he observed, had 'red, slightly horny' hands, 'surprisingly like a mechanic's'. At least the Queen, described by Beaton at her Coronation, displayed the hands of 'an artist, a ballerina, a sculptor or a surgeon': a paradoxical list of occupations, united by their disdain for grubby manual chores.

Beaton placed himself outside a society that, in defence of its utilitarian regime, imposed and policed a division between the sexes. Sometimes he dramatised his exclusion in gestures of abject self-pity; more often he was proudly deviant. During the 1930s he was photographed as a tattered scarecrow, his arms outstretched in a posture of crucifixion, with crows feeding on him. He poses as one of T.S. Eliot's hollow men, but he is also a voluntary martyr, accepting and relishing the scorn of the majority.

In 1946 Beaton photographed Garbo as a pierrot (plate 83). The costume announces a ghostly estrangement from reality, and a frigid immunity to the usual emotions (which was the aesthetic ailment of Schoenberg's Pierrot Lunaire). Beaton admired characters who, like actors, lurked on the disreputable social fringes, or in an illicit underground: courtesans, for instance. Gigi's aunt is one such character, along with the heroine of Frederick Ashton's ballet *Marguerite and Armand*, which he designed for Margot Fonteyn and Rudolf Nureyev in 1963, and the same character in Verdi's *La Traviata*, which he designed for the Metropolitan Opera three years later. In his book *Japanese* (1959), Beaton rhapsodised about the performances of the kabuki actor Utaemon, whom he had seen playing a prostitute and also a 'canonized transvestite'. The combination of sanctity and sexual irregularity was irresistible to him. When Beaton bathed his subjects in what he called a 'welter of radiance', he deified them, installing them in a hybrid, heterodox pantheon. He

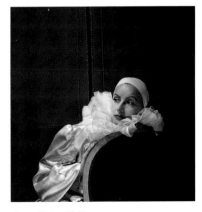

Greta Garbo, 1946
PLATE 83

likened Picasso to Buddha, thought that André Gide was 'impassive as a Chinese deity' (plate 79), and called the actress Ruth Gordon, bedecked with offerings from Garson Kanin, 'a little Burmese idol, studded with bulbous jewellery'. He consciously lavished this transfiguration on people who were scandalous. The star, as Quennell put it in his essay on Beaton, is 'a kind of sacred prostitute', on hire to us in our dreams. It is not only Garbo or Dietrich who, thanks to Beaton, do service as 'the world's imaginary mistress'. Johnny Weissmuller, availably prostrate in Beaton's 1932 portrait of him, is also ready for conscription (plate 26).

In *Cecil Beaton's New York*, first published in 1938, he defined the alternative society he had imagined. Here he advanced a 'theory of the pleasure class', which was his rhyming rejoinder to the economist Thorstein Veblen's theory of the leisure class. Capitalist work, according to Veblen, existed so as to subsidise a sumptuary idleness; the surfeit of industrial wealth led to the habit he called 'conspicuous consumption'. Veblen's notion of leisure was sedate, relaxed. Pleasure, in Beaton's revision of the theory, is more frantic, even orgiastic: his hedonistic New York shrilly pursues happiness in palatial cinemas and smoky night-clubs, at 'flesh shows' or prize-fights. This dizzy environment was his reproof to the more staid values of the home he had rejected. Mrs Vanderbilt and Mrs Astor upheld the proprieties in their Fifth Avenue mansions; Beaton was more excited by the celebrities who cheekily turned society inside out by allowing their 'intimate activities' to become public knowledge in the gossip columns. 'Café Society', Beaton said, 'does not live at home', and its members were 'people without dining-rooms, without sitting-rooms even – the people who live in their bedrooms and at a night-club'. They had no regard for a decorous privacy. Beaton delighted in a comment made by Adèle Astaire, Fred's sister, who had married into the English aristocracy (plate 18). A New York hostess asked her about her mother-in-law, the Duchess of Devonshire. 'She must be very stupid or very dull', replied Adèle, 'because I don't meet her about anywhere.'

Beaton was a climber and a snob, but these were aesthetic follies: he longed for acceptance by a society that existed only in his imagination. The snob worships symbols or fictions, which for him have a fetishistic power. When Beaton's parents moved to a street just west of Edgware Road, Cecil pleaded with his father to see if their telephone could be connected to the Mayfair exchange, rather than being listed with a Paddington prefix; the identifying letters were a matter of life or death. Alas, topography was against him. In his wryer moments he recognised

the absurdity of the whole elaborate imposture, and came to understand the insecurity of those whose position he envied. Why not invert the teetering ladder of privilege? In 1928 he assembled a gaggle of 'Intelligent Young Persons' for a group portrait; the subjects, himself included, lay on the floor beneath a leopard-skin rug as if snuggled into a communal bed, and he photographed the row of heads upside down. Socialites who attempted such stunts were acting out the collapse of the old, steady hierarchies. When the elderly Lady Mendl taught herself to stand on her head, Cole Porter seized on her acrobatics in 1934 as a symptom of the moral relativism of the age:

> When you hear that Lady Mendl standing up
> Now turns a handspring landing up
> On her toes –
> Anything goes!

Beaton's snobbery concealed an ironic scepticism, even a satiric contempt. In 1930 Emerald Cunard, alerted to his untrustworthiness, used his first book of society portraits to light the fire. She impaled it on her poker as it blackened in the grate, and called him – perhaps because he had impertinently described her 'perfect legs' – a 'low fellow'. In 1938 he was discharged by *Vogue* when some anti-Semitic slurs were detected in the lettering he added to a sketch of the New York social round. The injurious words could only be seen with a magnifying glass, but why had Beaton secreted them there? Because, like a deft spy or a criminal who believes he can outsmart the law, he thought he could get away with it. Artists, as incorrigible as children, are supposed to enjoy a special licence. The game he played was dangerous and duplicitous: he genuflected to his subjects, while reserving the right to deride them.

Like the bossy party organiser Elsa Maxwell, Beaton capriciously redefined society and made up his own criteria for admission to it. In a *Vogue* article, Maxwell outlined her recipe for a successful party. Bourgeois conventions could be ignored; wealth was no guarantee of acceptability, and hostesses should beware of extending invitations out of 'emotional kindness'. As for bores, Maxwell recommended euthanasia: round them up and exterminate them with 'a deadly laughing gas'. Only 'the great and glorious artists in that wonderful world of make-believe' – bright young things like the aristocratic bohemians under Beaton's rug – were welcome. For her Barnyard Party at the Waldorf Astoria she ushered a herd of cows into the ballroom, and she once commanded the Italian nobility to dress up as babies. Beaton

applauded Maxwell's rowdily vindictive practical jokes on the society to which she imperiously gave orders, but inevitably, because they were rivals, he turned on her. She was, he said, a snob who now waged war on snobs; since the same was true of Beaton himself, he had to make war on her. At a ball in Venice in 1961 he described her in his diary looking 'like a terrified buffalo as she was aided to the entrance', and he also photographed her resembling a jowly, rabidly discontented pug dog. Beaton's art relied on pretences, but he could see through them; his eye was cruel.

He suffered when his mother's plaintive annual request for tickets to the Royal Enclosure at Ascot was repeatedly turned down. When at last he managed to gain admission to Ascot, he found that 'the grand ladies in their fantastic dresses and the exclusiveness had all gone'. His presence there was a symptom of the democratisation he despised. Why would he want to belong to the kind of club that would admit someone like him to membership? He therefore staged a stealthy assault on the sacred precinct when he designed his own sleekly elegant, austerely monochromatic Ascot for *My Fair Lady*. This was, he said, his 'wish-fulfilling opportunity to re-create the world as I remembered it … in 1914'; having indulged his nostalgia, he enjoyed the acts of subversion that ravaged the idyll. Eliza screeches when the horses – like Elsa Maxwell's cows lumbering across the parquet floor – gallop by, and compounds the breach of decorum by uttering, in her acquired upper-class accent, a forbidden word. Beaton's Ascot derived from a striped marquee and fenced enclosure he had designed for the steeplechase in Julien Duvivier's 1948 film of *Anna Karenina*. There too, propriety was outraged by the heroine's reaction to the race – although the excitability of Vivien Leigh's Anna betrays her sexual liaison with Vronsky (plate 86), whereas Eliza's outburst is a merely a social solecism and goes unblamed. Beaton was forever constructing artificial Arcadias, then encouraging his subjects to behave disgracefully and risk expulsion.

In 1957 Beaton was intrigued by the clash of aesthetic rigour and bodily vulgarity at a tea ceremony in Japan. The ritual prescribed and refined every gesture, yet the tea was imbibed, he reported, with 'shockingly loud sips'. In the same way, he justified the shade of 'shocking pink' merchandised by the designer Schiaparelli, and the rough materials she used in her clothes. She should be praised, he said, for 'inventing her own particular form of ugliness and shocking a great many people'. For Beaton, these were legitimate aims. Society renews itself by recruiting from below, as when Mrs Higgins' guests adopt Eliza's racy slang; art develops by confounding traditional definitions of beauty and incorporating abnormality.

Sizing up Audrey Hepburn, Beaton noticed that 'her nose and jawline do not conform to the golden rule of Praxiteles'. Her eyes, incongruously unclassical, were a quotation from a Flemish painting. To this she added 'flat Mongolian features' and a neck he thought scraggy. But, as Hepburn conceded in a note she sent to him after a wardrobe test for *My Fair Lady*, he made her look beautiful.

Such revisions of an aesthetic norm issued a challenge to moral standards. Beaton's *The Glass of Fashion*, while chronicling changes in dress as 'Victorian bourgeois security' gave way to 'febrile modernity', is actually a history of sexual conduct. Its heroines are disreputable women – Colette's cocottes, the rapacious opera singer Lina Cavalieri – who triumphantly compel the world to condone them; no-one who imitates their clothes, their hairstyles or their slang can pretend to condemn their behaviour. The book acclaims the racy actress Gaby Deslys for having 'created a morality of her own immorality'. Beaton practised similar transvaluations in his portraiture, and made sure that he drew attention to his effrontery. Lady Ottoline Morrell, photographed against the backdrop of a seething jungle, looks as shrewd and unsocialised as a gypsy (plate 21). Nancy Cunard's tribal accoutrements – a bulbous necklace, those onerous bracelets – announce her annexation of Africa (plate 19). This was the woman whose enthusiasm for negritude led her to take up with a series of black lovers; the innovation was scandalous at first, but soon became fashionable. The polka dot pattern on the screen behind her shows that black and white, as in photography, are interdependent, perhaps even reversible, rather than being opposites. Beaton found the same stylish sedition in Mick Jagger, who was simultaneously 'archangel and satyr', an innocent calf who could be 'ugly, repellent, vicious, decadent': Dorian Gray's bland expression warps, and Beaton has a glimpse of the painting hidden upstairs. In one of Beaton's portraits, Jagger clasps his hands as if in prayer. But he is lit from below, and looks – despite his guileless face – sinister and even devilish, like a corrupt altar boy. Bianca Jagger, stretched on the tiles in Beaton's conservatory, also vacillates between moral extremes. Her pointed finger is a vertical, virtuous signal, directed upwards like a Madonna or a saint, or the religious figure in Titian's allegory of sacred and profane love. But the gesture is a sacrilege. Half-undressed, she lies beside a pool of lilies that flagrantly exhibit their genitalia (plate 149).

Beaton's visual portraits had a duty to flatter. This gave him all the more reason to tell the unlovely truth in his supplementary verbal portraits. In the photographs of actresses he admired as a boy, he was delighted by the stip-

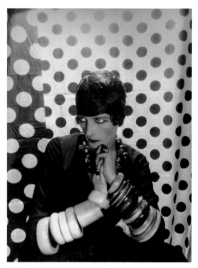

Nancy Cunard, 1929
PLATE 19

pled evidence of retouching: the portraitist was duty-bound to erase the incursions of age, and to tighten sagging flesh. Yet his words drew attention, with Swiftian savagery, to the blight his images conscientiously brushed away. On opening night of the Metropolitan Opera season in 1937, Beaton ridiculed the superannuated beldames whose marmalade-coloured wigs did not quite cover a 'web of skin-stitches over the temples'. A coven of witches cackled in the vestibule, peering into their vanity cases as if 'hungrily bending over their cauldrons'. When Beaton designed Puccini's *Turandot* for the Met in 1961, he applied this equivocal vision to the opera's protagonists. As the homicidal princess, Birgit Nilsson – with a blanched face, fingers elongated to pincers, and a head-dress of jewelled, jabbing spikes – looked like a Chinese vampire, alluring but terrifying. As the prince who thaws her with his incendiary high Cs, Franco Corelli, squeezed into clinging tights, played a phallic symbol. In his diary, Beaton relegated his beauties to a bestiary. He nicknamed Nilsson 'the Hippo' and Corelli 'the Gorilla'; his descriptions emphasised the soprano's squint eyes and hook nose, or the 'dark black curls' that sprouted at the back of the tenor's neck.

Beaton's aesthetic conscience made a sadist of him. In *My Fair Lady*, the sanctimonious rites of beautification were preceded by a realistic sullying. Before Hepburn metamorphosed into the floral centre-piece at the Embassy ball, she had to suffer another transformation. For her scenes as a Covent Garden guttersnipe, her hair was smeared with grease, then had soil massaged into it. 'The effect', Beaton noted, 'is really dirty, and psychologically must be very depressing.' But he approved of such initiations. Beauty entailed penitential sacrifice, and its cosmetic routines, like a nun's self-flagellation, acquired extra value if they were painful. In Japan, he watched a chef slice off a crab's claws 'with the precision of the world's best pedicure'. No wonder some of his subjects reacted so warily to his camera. He reported that Garbo, consenting to be photographed because she needed some snaps for her passport, stiffened as if he were a one-man firing squad. Hepburn raises her hand as if defending herself against a journalistic flashbulb (plate 105), and Marilyn Monroe, pitiably unguarded with a flower crushed against her chest, lies back and entreats him to be gentle (plate 122).

Beverley Nichols, reviewing Beaton's *Book of Beauty* in 1930, picked apart the faces Beaton portrayed, as if he were Picasso jumbling organs and appendages. Why, Nichols asked, 'should an oval surface, surmounted with a matty substance, pierced with two dark holes, slashed with a red opening, decorated with a thing so odd that "nose" is the only word for it', possess such value? Unless seen with the doting gaze of a lover or a photographer, faces were a garbled 'patchwork', pitted with orifices. This demystified view recurred when Beaton looked at bodies, which he sectioned for appraisal. In his diary he noted that Garbo, as well as those unworthy hands, had ankles and legs with 'the uneven, somewhat scrawny look of a waif's or of certain poor, older people'. If beauty means perfection, as he contended, then no human being can ever possess it.

Frustrated by physiological limitations, Beaton dreamed of redesigning humanity. He illustrated *Near East* (1943), his chronicle of a wartime photographic expedition, with a series of witty mechanomorphic assemblages that he called 'Legs and Machines': human legs descend from the bellies of planes, or stick out beneath the fender of a parked car. In 1928 he sketched a costume for a futuristic aviatrix attending a ball at Claridges; her uniform of 'white glacé kid' was 'painted with coloured aeroplanes and spare parts'. Marcel Duchamp's mechanistic bride had become indistinguishable from her attendant bachelors: Beaton predicted that the woman of the future would shave her head, so the wearer of the costume used a bald wig, supposedly as aerodynamic as a pilot's skull cap. In this brave new world, the sexes would merge, and the soft, inefficient body would undergo re-engineering. Auditioning extras for the film of *My Fair Lady*, he joked about this ghoulish surgery: 'Little did I realize that I would be earning my living by playing a sort of game of heads, bodies and legs with human beings.' One candidate for a walk-on in the film possessed a good head but an unacceptable body, while another moved well but had an inappropriate face. Even if the parts of physique made up an acceptable whole, the clothes Beaton had designed possibly jarred. Rejects vowed to improve their 'lower portions' to balance 'the upper parts', or to subsist on apple juice and cottage cheese so as to wriggle into a dress. Oliver Messel in a 1929 portrait already seems adept at the physiological juggling Beaton practised on the set of *My Fair Lady*. He has neatly sliced off the face of a chubby wooden cherub, which uncomplainingly lolls on the floor beside him. Messel might be about to exchange faces with the *putto*, except that there is no point: the face he wears on his neck is as serenely insentient as the one he holds in his hand. For good measure, he has a glittery mask ready, which perhaps he intends to place over the cherub's empty eye-sockets.

Frankenstein pieced his monster together on the operating table, using organs and limbs scavenged from corpses. Beaton's mannequins or manikins were equally eclectic, though they never quite cohered. Grand hostesses in some of his earliest portraits consented to lose their heads, which were preserved beneath glass domes. In 1940 during the Blitz he photographed scenes of bloodless carnage among the rubble of West End dress shops. A shop-window dummy's severed head rolls away, while a tangle of emaciated wooden legs and twisted arms belonging to her colleagues lies scattered on the pavement, with a length of dirtied chiffon as its rough shroud.

The hats worn by Beaton's subjects often look like attempts to grow alternative heads. In a New York restaurant, he saw customers parade in a range of bonnets for which rooks, pheasants and parrots had been ruthlessly gunned down; he admired these morbid, unnatural trophies. The faces of the race-goers in *My Fair Lady* are all but obliterated by their extravagant plumage. A bloom sprouts from Coco Chanel's brain in Beaton's 1937 portrait (plate 40), and at a ball in Venice in 1951, it is the skyscraping fronds of Mrs Reginald Fellowes that entitle her to impersonate America (plate 92). In *Gigi*, Leslie Caron makes her debut at Maxim's with a diamanté half-moon in her piled-up hair: ready for her sexual initiation, she is defined by the ornament as a queen of the night. In *Near East*, Beaton told a story about a German prisoner in Libya and his Polish captors as if it were a contest between the headgear of the combatants. The young Nazi is laughably enfeebled by his 'soft caskette hat', which recalls 'the feminine fashions of the last war'; brought back to camp for interrogation, he lunges menacingly at the three men by whom he will be questioned. He backs away when he sees their hats on the table, and recognises that they are 'those of Polish officers'. He breaks down in terror, 'haunted by … those hats'. Authority, as ever in Beaton's imagined society, is sartorial: the Prussian thug is 'brought to this condition of funk by the spectacle of those three Polish hats'.

On his trip through the Egyptian desert, Beaton read military camouflage as costume, since it too told beguiling lies. 'Often one sees aircraft wearing floating draperies, or veiled in fluttering nets', he reported. Much as he treasured the deception, he enjoyed stripping away those gauzy, filmy appearances. Hence his daring agnosticism about fashion itself. The New Look promoted by Dior in 1947 revealed, Beaton said, that 'fashion is *au fond* ridiculous and perverse'. He waspishly referred to the unchaste and bisexual Lady Mendl as 'a *religieuse*: fashion was her god'. Unfortunately,

the god to whom she devoted herself was non-existent. With its rites of spring, fashion preaches cyclical renewal, and sells the notion of a serial reincarnation that can – if you are credulous enough, and have enough money to spend – ensure that you outwit time. Beaton sympathised with this fond delusion, but refused to be taken in by it. He knew that the impatient tempo of fashion accelerates the cycle and uses life up. The task of the designer and couturier is, Beaton said, 'to anticipate taste, to run before it and often create it' (as he attempted to do when he sketched the female flyer). His own imagination pined for the past rather than looking ahead to the future. Mortality, which fashion seeks to deny by perpetuating youth, haunts his images, and the prospect of what lies ahead turns childhood into a menaced, insecure condition. Eileen Dunne, not yet four, is already a victim of history in Beaton's 1940 portrait. Wounded by shrapnel after a bombing raid, she sits up in the iron cage of a bed, cradles a balding teddy bear, and with her other hand grips a mouth that has fallen open in stupefaction, not juvenile wonder (plate 51).

Beaton could never forget time's enmity nor its implacability. Travelling in the tropics, he longed for the English summer, which, like beauty, was precious because ephemeral. On a film set, he shuddered when the technicians scrambled to catch the fleeting sun, because their 'frenzied rush for the golden seconds' was another memento mori. He often posed his subjects as corpses – Edith Sitwell lying in state in a kimono between two presumably grieving putti, or Stephen Tennant in repose on a satiny bier – because he saw an analogy between the photographer's art and that of the taxidermist: both deal in the aspect of eternity. A keenly perceptive comment he made about Cole Porter applies to his own case. Beneath Porter's brittly topical wit, Beaton sensed the depression that stalked 'all creators who work in temporal media'. The body is the temporal medium in which we are all condemned to work.

Fashion, which supplies that body with a defence against obsolescence, conjures a temporary meaning and an enhanced value out of nothing at all. Chanel's little black dresses, for instance, were minimal, negligible things. Deliberately using a philosophical term, Beaton called Chanel 'virtually nihilistic', because in her view 'the clothes do not really matter … it is the way you look that counts'. That look is a fortuitous air, a matter of posture or poise; you cannot purchase it. In 1969 Beaton ventured to redesign Chanel clothes for a musical in which Katharine Hepburn played Coco. On stage, he explained, the real items would have resembled paltry donations to a thrift shop. He gleefully related a story about the *Vogue* edi-

tor Diana Vreeland, who turned a mishap into a nihilistic epiphany: when she sent a synthetic dress to the dry cleaner, it dissolved into nothing. Beaton's frivolity often unexpectedly gives way to desolation, which is bleakly soothing. In 1957, on a visit to a Zen garden of raked sand in Kyoto, he felt he was confronting 'the nothingness of life'. Mystical insights or religious intimations recur in his comments on photography, although his irony allowed him to pretend that he was merely joking. He likened the gaping, gloomy sound stages in Hollywood studios to cathedrals, well aware that the deities they housed were voluptuously pagan. When the Latin patriarch in Jerusalem declared himself unhappy with his pose during a photographic session, Beaton used the churchman's own terminology against him: 'Have more faith in me, Your Beatitude', he demanded. Faith, rather than mere trust, was what he asked for. Was he not communing with spirits, offering glimpses of heaven? He admired the way in which the society portraitist Baron de Meyer beatified his subjects, enveloping them in 'a glorious halo, their hair an aureole'; the quest for a manifestation of spirit, like shimmering ectoplasm, made Beaton himself speak of a 'photographic séance' with Marlene Dietrich.

He knew how awesome his responsibility was. 'The fashion photographer's job', as he put it, 'is to stage an apotheosis.' An apotheosis is an act of worship, and its purpose is to invent a god. The photographer lavishes attention on people who are somehow photogenic, which means that what happened at one of Beaton's sessions was a kind of photogenesis: born of light, luminaries blaze into being in the dark room of the camera, like Laurence Olivier and John Gielgud in 1935 as Romeo and Mercutio, their outspread arms silhouetted against a white backdrop, or Beaton's sister Baba in 1925, posed before a screen of metal foil that glares like molten silver. The Duke of Windsor on the eve of his marriage seemed to Beaton to be 'radiant – his hair ruffled gold, his complexion clear and sunburnt'. Charisma, which Beaton's beauties were bound to possess, is a theological term, referring to a gift of grace, an emanation of the holy spirit. Or was that radiant favour conceded by the photographer? Divinities, seen like this, do not descend to us from a higher realm. It is photographers who capriciously choose to ensky them. In New York, Beaton studied the treatments a beauty clinic administered to a 'potential Venus'; on his first trip to Hollywood, he saw Apollos and Venuses with 'classic oval faces that might sit to Praxiteles' lounging on the sidewalk. His first portraits of film stars placed them beside carpenters' ladders or skeletal scaffolding in bare sound stages. An arc light that he trained on Tallulah Bankhead scours her face from above, digging trenches of shadow, but does not diminish her allure.

He then took his subjects outdoors into the pitiless California sun: after laying bare the machinery of illusion on which these dreamy, visionary beings relied, he enticed them to risk themselves without its protection. Photography, as Beaton said, was 'a marriage between the camera and the essence of light'; he thought of it as a mystic marriage.

Beaton's own sexual adventures were a kind of divination. Taking a weekend off from *My Fair Lady*, he flew from Los Angeles to San Francisco, where he met a young man with whom he began an affair. The encounter occurred in a louche club called The Toolbox. Despite his compulsory black leather, this new lover looked 'golden and pure'; watching him sleep, Beaton thought he had brought home the Apollo Belvedere. Keeping company with 'the arch-goddess' Garbo in Hollywood, he said he 'felt

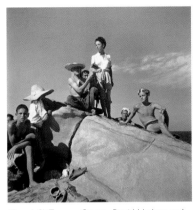

(from left) Truman Capote, David Herbert and Jane Bowles in Morocco, 1949
PLATE 90

Olympian while the lives of others were as pigmies'. But Apollo the sun god materialised in the subterranean darkness of a bar, and Venus travelled down to earth in the elevator of a New York hotel. As Beaton waited for Garbo on the ground floor of the Ritz Tower, he watched the hand of the indicator above the lift door announce 'the arrival on *terra firma* of the goddess from the skies'. In both cases, the sublime creatures delevitated, whereas they should have remained untouchably aloof and aloft. Beaton ruined his dream by attempting to anchor it in reality.

His sharp eye registered the way others aspired to sanctity, hastily consecrating their household effects. The priest who married the Duke and Duchess of Windsor in a borrowed French chateau in 1937 refused to officiate unless he could stand at an altar. The Duke first suggested using a drinks table, but they settled on an ornate chest with a frieze of fat carved caryatids. Mrs Simpson then went searching for an altar cloth, if only to cover up those 'extra women', and her whining maid had to unpack a linen trunk to find one. When the solicitor placed some candlesticks on the ersatz altar, Mrs Simpson protested that they had a profaner task to perform: they were needed for the dinner table. Then someone noticed that there was no crucifix. The chateau was ransacked without success, so a cross had to be requisitioned from the British Embassy in Paris. At last, after being photographed by Beaton, the Duke and Mrs Simpson were able to go through with their 'religious ceremony', staged in a temporary,

unhallowed chapel that they had rigged up by redeploying the furniture. Beaton, knowingly irreverent, often distributed people in group photographs to suggest what a Renaissance painter would have called a *sacra conversazione*. In Morocco in 1949, his three friends perform in a charade that mocks the Nativity (plate 90). The diminutive Jane Bowles stands at the apex of a pyramid, with David Herbert – his towel wrapped into a vaguely Biblical head-dress – deferentially lurking in the background. Truman Capote is their perverse child, already smoking: Beaton thought of Capote as 'a young troglodyte, a baby Hercules', who seemed gigantic though he was only five feet tall. The local boys have come to gape, if not to worship at the shrine; the goat also refuses to kneel, and haughtily offers its profile as if it were the centre of the photograph. The hot, empty sky contains no guiding star. At Warhol's Factory in 1969, Brigid Polk plays the Madonna, flaunting a bare breast – whom does she intend to nurture? – to distinguish herself from the bouffant drag queen Candy Darling (plate 142). Warhol, the paterfamilias in the platinum wig, had been shot a year before, and Beaton likened him to a zombie, affectless and hollow-eyed; his nickname was Drella, a compound of Cinderella and Dracula. This altarpiece celebrates a Christ who is undead, rather than an arisen saviour.

Monarchs are supposedly the deputies anointed by the Lord, and Beaton fervently believed in their divine right. But he also understood that their sovereignty depended on the image they projected. They knew it too, as the Duke of Windsor revealed when he told Beaton about his struggle to convince the Royal Mint that the currency of the realm should show his left profile, which he considered to be his good side. The application of holy oil at Westminster Abbey in 1953 was followed immediately by a photographic session at Buckingham Palace, with the new Queen posed against what Beaton called 'my "blow-up" Abbey background', a fuzzy screen that represented the nave in an unnaturally steep, receding perspective. The Archbishop of Canterbury conferred one kind of legitimacy, but the process had to be completed by Beaton, whose photographs appeared in the papers that evening while his written account of the ceremony was wired to the colonies. As usual, he glimpsed a reality that belied the fiction he was helping to create. In his diary he reported that the Queen's nose looked chilly; her eyes were weary, and she stoically admitted that her crown was 'rather heavy'.

By 1953, travel had made a relativist of Beaton. Having met and photographed so many kings and queens, he was inclined to mistrust the sacred pedigrees of which they all boasted. Republican America had its

unofficial monarch, Mrs Cornelius Vanderbilt, 'crowned Queen of New York Society by the newspapers'; a crimson velvet tea-gown, Beaton said, was her robe of state. On his wartime journey through the Middle East he photographed Feisal II, the precocious king of Iraq: a child in play clothes, perched on a corner of his throne, his head unaligned with the embroidered crown that hovers above it on a curtain (plate 75). Later came the sovereign of an imaginary realm, the Queen of Transylvania in *My Fair Lady*. Beaton wanted her to be 'a personage of enormous authority', and badgered Cukor to cast the retired operetta singer Fritzi Massary. She possessed, he thought, a 'grace' or charisma that is acquired only 'by actresses accustomed to the dark mysteries of backstage, or by Royalty'. Once more, he treated the professions as if they were interchangeable. Massary wanted too much money, and instead the part went to Bina Rothschild, personally crowned by Beaton with a triple-pronged tiara, a three-tiered necklace with diamonds as big as walnuts, and a choking dog collar. Regal status – whether in Transylvania or Hollywood, in Brilliantia or in Great Britain – derived from appearance.

Beaton wished a collateral royal lineage on his own family, claiming descent from a lady-in-waiting who attended Mary, Queen of Scots. But he ironically discounted such pretensions in *My Royal Past*, which purported to be the reminiscences of Baroness von Bülop, a nonentity with a spurious title; for the illustrations, Beaton's friends donned drag to pose as members of the obscure royal house. He published the book in 1939, a few months after his photographic session with Queen Elizabeth at Buckingham Palace. The coincidence was typical of the double game he played. He even lured the real monarch into some fictitious role-playing, which meant that she had to divest herself of all royal trappings. After completing the portraits in the state rooms, Beaton coaxed the Queen to remove her tiara and photographed her in the deserted garden of the palace, where she held up a flimsy parasol against the darkening sky as an impertinent breeze tugged at her dress. George VI, when he saw the prints, said they should be entitled 'The Unsuccessful Hostess'.

One of the episodes in the ballet *Les Illuminations* dramatised a poem in which Rimbaud identifies royalty with exhibitionism. A woman in a public square screeches that she wants to be queen, and her friends indulge her. According to Rimbaud, they spend the entire morning being vaingloriously royal; after that, they revert to commonness. Reducing the rank to a metaphor, Beaton paid homage to Garbo's 'royalty of form'. The notion made an ingenious connection between politics and aesthetics, but it

proved to be painfully misleading. Constitutionally, kings and queens have two bodies. The office – symbolised by the robes, the crown or the Spiritual Sword that impressed Beaton at the Coronation – is immortal; an orderly succession therefore demonstrates the prompt resurrection of the dead. But the individual office-holder remains pathetically mortal. Shakespeare's kings complain about the disparity; Queen Elizabeth II, as she told Beaton, had a weary head after wearing the crown for only three hours. Form cannot be immortal. If Garbo's royalty was physiognomic, the power it gave her had no secure basis. That was why she withdrew prematurely from public view, and also why she so teasingly evaded Beaton's camera and deflected his proposals of marriage. Her face was her sole asset, yet every day it was diminished, eaten away by time. How could the living, ageing woman compete with the luminosity of the enlarged, untemporal face on the screen? It was the illusion, of course, that Beaton had fallen in love with; he could not cope with the querulous, fugitive, neurotic woman.

Beaton's camera caught Garbo's momentary moods, as she laughed in her Hollywood garden or pensively smoked in his New York hotel, but those snapshots chronicled her lapse into mortality. In 1946 he made a more formal portrait, in profile, as if her face were to be engraved on the currency of Brilliantia. Her head has been separated from the rest of her, and this, together with her serpentine hair, suggests that she might be the Medusa after Perseus decapitates her (plate 82). She already needs the help of a photographic beautician: retouching has restored the line of her jaw and neck, blurred by age. Garbo was a victim of the 'face aesthetics' preached by that New York beauty parlour. In 1959 Beaton saw her get up from a sofa to consult a mirror: 'No, she had not lost her beauty.' Two years later, he checked on the state of her face, which 'still had a quality that no other New York face has' – but for how much longer? In 1965, on a yachting trip in the Mediterranean, he finally allowed the face to crumble: he watched, 'hawklike', as the 'cruel harsh sunlight' took inventory of 'every crinkle and crevice'. Garbo had her revenge on a last visit to Wiltshire in 1975, when a stroke had left Beaton partly paralysed and impaired his speech. After their last goodbye, she said to his secretary, 'I couldn't have married him, could I? Him being like this!' The withering aestheticism of the remark recalled Beaton at his most superficial, and exposed Garbo's own emotional anaesthesia: in her calculation, she was justified in refusing to begin a relationship with someone who, thirty years later, might fall messily and embarrassingly ill. The art of portraiture left both of them unreconciled to life outside the frame. Beaton, after all, was anachronistically alarmed by

Audrey Hepburn's high spirits. Watching her pull faces, he predicted that 'she will not be a beautiful old woman'. Cancer kept his grim prophecy from coming true: she did not live to be old.

Roland Barthes, contrasting two of Beaton's heroines, said in 1957 that 'the face of Garbo is an Idea, that of Hepburn, an Event'. The idea is capitalised because it is Platonic, abstract, almost disembodied; the event – mobile, unstable, part of a temporal flux – belongs to Barthes' own time, the decade of existentialism and action painting. In Beaton's experience of the two women, Barthes' distinction between Garbo as concept and Hepburn as substance did not hold good. In Garbo's case, the idea existed only in the cinema. The face she lived in was as eventful as Hepburn's, mined by mental stress, liable to seismic rifts. Hepburn's role in *My Fair Lady* put the notion to a further test. Her face at first, as the grimy flower girl blubbers in the church portico, is rubbery, contorted; at the ball, schooled by Higgins (and dressed by Beaton), she displays a face that is calm, unclouded, as distantly benign as that of a royal personage waving to a crowd. The mask cracks at the end, when she hurls Higgins' slippers at him and demands that he reciprocate her feelings.

Her tantrum, however, is a reminder of Beaton's qualms about the fable of Pygmalion. The sculptor carved an ideal woman, then entreated her to descend from her pedestal; stone became fleshly and palpable, and the effigy turned into his lover. This is how Ashton's *Les Illuminations* began: the dancer playing Rimbaud touched the frozen figures that represented his fantasies, and quickened them into life. But Beaton's artistic preferences were different. Like Pygmalion in reverse, he started with the living, moving body, then willed it to take on the untouchable stasis of the photographic image, or even sometimes of the statue. One afternoon in New York in 1947 he was thrilled when Garbo drifted into 'the half light' and became 'the living embodiment of her "stills"'. On another occasion he planned to have a cushion that her head had dented cast in bronze: the souvenir, at least, would have a statuesque permanence, after the skittish owner of the head had fled. Beaton aligned Chanel with a carved blackamoor in his 1937 portrait (plate 40), and in 1967 got Twiggy to perch on a marble column as if she were an extension of it (plate 127). He often saw people as candidates for statuary. It was not enough for his San Francisco conquest to be Apollonian; he had to resemble the Apollo Belvedere, a sculpted god. On the ship sailing to Africa in 1942, sailors sleeping on deck in their blankets 'looked like fragments of Greek statues'. Why fragments? – as always, Beaton enjoyed breaking up the bodily whole and

studying its parts separately. In Egypt the women collecting water from the river were 'proud caryatids', though unfortunately the vessels they shouldered were not earthenware ewers but 'battered old Shell petrol cans'. That disappointment regularly repeated itself. Casting the extras for *My Fair Lady*, Beaton was enchanted by a young Englishwoman, whose svelte body made 'Elizabeth Taylor a suet pudding in comparison'. Then she fatally betrayed signs of life and ruined her 'calm, Canova marble serenity' by chewing gum.

As he grew older, Beaton came to suspect, with twinges of distaste and remorse, that his worship of the impervious face was a kind of necrophilia. Hence his portrait of Pavlova's death mask, made in 1960: flesh has retracted to lay bare her fine, frail bones. He watched as decrepit beauties battled to redesign themselves. Lady Mendl's much-lifted face had the 'effect of carved ivory', and a nonogenarian Venetian courtesan replaced her fading complexion with 'heavy applications of "enamel"' and dipped her auburn hair in 'a strong rejuvenating dye'. Other antique crones seemed to have risen from their graves to attend just one more party. Rose Macaulay was 'a galvanised corpse', Karen Blixen 'a gesticulating cadaver'. In 1948 he paid a visit to Emerald Cunard's dead body, which lay in state at the Dorchester Hotel, and appraised the bundle on the bed as 'a strange object of art'. Now that all colour had drained from her, she appeared, like Lady Mendl, to be 'carved in deep ivory: teeth, lips, eyelids and cheeks were all made of ivory'. Or was she, like Lopokova, a waxwork? Beaton obstinately restated his creed, which he attributed to her: 'Emerald, a worshipper of beauty until the end, made her life into a work of art.' But living things cannot be constrained by aesthetic rules, while a corpse is a sorry substitute for a classical statue.

Perhaps because Beaton had to cover up the skull beneath the skin in his photographic portraits, he admired painted portraits that could dabble more intimately in the psychological quirks and moral debilities of the subject. Paint is wet, organic, as textured as skin; the medium is as mortal as the faces it represents. Beaton preserved surfaces, whereas Graham Sutherland, photographed at work on his painting of Somerset Maugham in 1949, has given an account of the novelist as if from behind that taut, scornful face. A photograph records only a moment, but the painting, like Maugham's seasoned and cynically habitual expression, is the work of time. The three alternative sketches of Maugham's head, one of them in profile, show Sutherland approaching the subject from different angles and in different moods. In another photograph from the same session,

Sutherland has moved to the window, put down his cigarette, and crossed his arms in an exact, mocking duplication of Maugham's pose. He looks out, with the sun on his young face; the old man in the painting lurks behind him in the shadows, belonging to the past. Beaton was impressed by Sutherland's perceptiveness, and by Maugham's forbearance. The painter, he said, had 'made Willie as sour as a quince – yet Willie seems delighted'. Beaton's verbal portraits could cut as deeply as the painting because, as in this tart allusion to quince, they relied on metaphor. The portraitist was less nonchalant when he saw himself portrayed by others. An enfeebled Augustus John rendered Beaton's face as a hysterical mess of 'entrail-coloured brush strokes', and in 1960 a portrait by Francis Bacon presented Beaton to himself as 'a swollen mass of raw meat and fatty tissues', as if turning him inside out: the result so upset him that Bacon, feeling guilty, destroyed the painting.

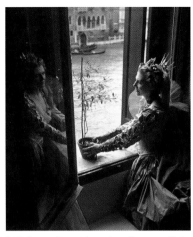

Lady Diana Cooper dressed as Cleopatra, Venice
PLATE 93

Mirrors – indispensable to the young narcissist, like the pool in Beaton's conservatory where his youthful, nubile guests admired themselves – now made alarming portraits of their own. In 1955 Beaton had one of his regular haircuts at Selfridges. The barber was the same 'nice, carroty Mr Massey' who in 1927 had ravished him with his tickling fingers. This time the experience was less pleasant. Massey swivelled the chair, and Beaton caught sight of himself in the adjacent mirrors: old, bloated, with bags drooping beneath his eyes. Even more incriminatingly, a hand-mirror – in which Massey invited him to check the way the nape of his neck had been clipped – showed Beaton 'a semi-bald man of twice my age and size'. This stranger, he had to admit, was himself. 'Oh, Christ!' he moaned. 'What can I do to be saved?' It was, whether or not he rewrote the exclamation when he came to publish his diary, a revealing outburst. He did not ask how he could save his receding hairline or his expanding waist. In his Wildean cry from the depths, he begged for salvation. The mirror scared Beaton into profundity.

During his courtship of Garbo, the two of them 'indulged', he remembered, 'in a dangerous game of staring full-face at each other'. How could such a childish pastime be dangerous? The danger lay in the disintegration of the face, which occurs when you scrutinise it too closely. Its features swirl out

of place, and innocuous details – those cavities enumerated by Beverley Nichols in 1930 – become foul deformities. Identity perishes, and if the face you are staring at is Garbo's, the very notion of divinity is devalued and defamed before your eyes. 'Face aesthetics' had a responsibility beyond toning the skin or tightening it; when Beaton pleaded to be saved, he was hoping for the salvation of the face. His concern went beyond vanity. Faces on coins are emblems of value; in Beaton's portraits, the face is a medallion certifying the precious state of individuality – and this, he believed, was being exterminated by the society around him. In 1957 he published an anthology of his work entitled *The Face of the World*. By then he was living in a world that he considered to be faceless.

Fritz Lang in 1926 praised the cinema for having sponsored 'the rediscovery of the human face'. Never had it been enlarged to such a size, or scrutinised in such detail. Silent films placed on view planetary visages, like moons that excited mystical longings: the spectral Garbo, the radiantly chilly Louise Brooks, Chaplin with his woebegone anaemic pallor. These mythic creatures were necessarily monochrome, their white flesh blackened, as if scorched, by their eyes and mouths. As Jean Cocteau argued in 1953, they could not survive being photographed in colour: 'the talking statues will become polychrome, closer to reality. They will lose some of their mystery.' Beaton shared that concern, and had a conversation about it with the director Jean Renoir in 1963 while working on *My Fair Lady*. They agreed that the invention of panchromatic film had tugged those abstract, simplified lunar faces down to earth and tethered them to vulgar reality. Hollywood now, Beaton said, made films 'in antiseptic colour displaying the bright brassy hair and freckles of Doris Day'. What he grieved over was the loss of singularity, the lapse from the divine exclusiveness of Garbo to the squeaky demotic jollity of Doris Day. A mass society massproduced stars, which soon burned out and were replaced: hence the so-called 'superstars', mostly nobodies with no discernible talent, manufactured at Warhol's Factory.

Beaton, having created himself, prized his unrepeatable oddity. After the months he spent merged in a military unit during 1942, he was relieved to be discharged from duty and allowed 'to find again my own individuality'. This proud self-sufficiency, which turns personal mannerisms into a style that others emulate, was for him the secret of being fashionable: it emphasised, as he said in 1954, a quality that is 'intensely individual'. Once more he deployed the jargon of existentialism – which stressed the self-dramatising antics of the lonely, tenuous ego – to account for activities that the

philosophers themselves might have scorned. Albert Camus in his tract *The Rebel*, published in 1951, commended the dandy for defiantly assert-ing human freedom, and praised the excesses of what he called 'stylization'. 'By the treatment that the artist imposes on reality', Camus said, 'he declares the intensity of his rejection of it.' At the end of *The Glass of Fashion*, Beaton vaguely acknowledged 'the modern forces of anxiety that would pull us apart', and wondered how to counter them as 'we seek with greater boldness and intensity to express our individuality'. A shop-ping trip for new clothes could not only make you a new person, as his plus fours once did, but might help to salvage the human race, resisting the drab regimentation that had overtaken the world.

Beaton complained that the people who should have represented the pure state of idiosyncrasy were not leading the way. Like Cocteau, he believed that photographic candour put an end to mystery, and he regretted the homely approachability of Audrey Hepburn, whom he called 'a troubled sprite in blue dungarees, a citizen Puck'. A colour photograph that he selected for his anthology *The Best of Beaton* in 1968 represented his view of a society in which personal distinction had been effaced. It shows a crowd of molecules, which turn out to be people crammed into the public square in Siena, where they are waiting for the Palio to begin. Beaton made the scene more palatable by giving it a metaphorical title: he called it 'Human Caviare', but his caption likened the minute, interchangeable heads and bodies to a dusty scattering of hundreds-and-thousands as well as to rare, delicious fish eggs. Less colourful and less appetising, the same spectacle depressed him as he sorted through a 'dingy' and 'dreary' multi-tude of human specimens in quest of extras for *My Fair Lady*. The candidates had committed a kind of mass suicide, disclaiming individual identity and in the process 'killing off' (as Beaton put it) the clothes he wanted them to wear. Their anonymity was a camouflage, reminiscent of the cowed, huddled behaviour of people in a totalitarian society. They knew that if they betrayed any distinguishing features they would be used only in one scene; to secure multiple engagements, they developed a 'pro-tective colouring', blurring into an 'unsocial mass'. Though the lumpen collective dismayed Beaton, he reserved the right to punish any of these expendable, supernumerary figures who seceded from the mob. At the first night of the Met's *Turandot*, he abused a chorus member who came on in the wrong costume. The downtrodden proletariat of Peking wore soiled grey tunics in the first act, changing to yellow and orange near the solar climax of the opera but the woman who enraged Beaton sported her orange dress in the first scene and marred his stage picture. He rushed

backstage and ripped her skirt off; the union only permitted the performance to continue after he had slavishly apologised.

The bumptious chorine was not allowed to join Beaton's elective aristocracy, whose members – Garbo and the Queen Mother, the Sitwells and Stephen Tennant, Jagger and Nureyev – possessed a quality he could only call 'romantic individualism'. Their aura was unmistakable, though hard to define. It glowed around them like a nimbus; it had probably been fabricated, with the photographer's help – like the muslin dress he designed for Hepburn's last scene in *My Fair Lady*, which struck 'the right mood of romantic individualism' – but its spirit escaped from the fabric and was invisible to any eye but the camera's. The 'pale pastel-mauve' dress, Beaton said, seemed 'like a froth built on Audrey'. Lighter than air, apparently seamless, it was a 'confection'. So was she, so was Beaton, and so were all the self-begotten phantoms he photographed. A grace so effervescent soon fades. As Beaton said of Lina Cavalieri's decline, 'the real tragedy of people is always lived out in time', and that tragedy lurks just outside his photographs. Once the image has been fixed, decay continues. Beaton sometimes helped the entropic process along, as when he tore apart his New York studio or his country house and took gloomy inventory of the tatty bric-à-brac from which he had made his deceptive magic. On another occasion, he was saddened when the demolition crew moved in prematurely. Just before he finished work on *My Fair Lady*, he took some friends to see the sets he had designed. The Embassy had already been stripped of its light fittings, its furniture sent back to the warehouse; even more distressingly, the 'glorious white *treillage* world of Ascot' had been ripped down and carted off to be burned. Ghosts of the people he had imagined or perhaps remembered were consumed in the flames: like a novelist, he had sent Cukor compressed biographies for the extras – a lord like a bedraggled cockatoo, an aristocratic matron who resembled 'a Boadicea skimming the waves'. Ascot was his equivalent of the Guermantes ball at the end of *A la Recherche du temps perdu*, when the dancers, whom Proust has known all his life, begin to decompose before his eyes.

The game Beaton played was one he knew he would lose. He sensed a similar misery in Cole Porter, who, as he said, 'combines the despair and the triumph of the Juggler of Notre Dame'. The remark – a personal testament and a self-vindication – refers to a medieval legend, retold by Anatole France. The monks at the Abbey of Cluny give shelter to a fairground juggler, who celebrates the Feast of the Assumption as best he can.

While his learned hosts paint or sculpt or sing or compose devotional verses to praise the Virgin, he can only juggle before the high altar. But it is he who receives the benediction, when the statue of Notre Dame – exactly like Lady Diana Cooper as the re-animated icon in *The Miracle* – smiles and stretches out a comforting hand. Beaton of course preferred statues that remained on their pedestals, rather than risking themselves in the lowly world of flesh and blood. At a society ball in Chicago, local women acted out the tableaux he had photographed for his *Book of Beauty*; retelling the story, Beaton inserted a proviso. The woman who played Lady Diana Cooper playing the Virgin was a little too eager to come to life. 'Not so fast!' cried the flustered organiser of the pageant. 'Remember you're the Madonna!' Immobile in its niche, the statue is safe from reality; inside the photographic frame, the image will never change.

Though this should be the triumph, Beaton could not help admitting the despair. Lady Diana Cooper, dressed as Tiepolo's Cleopatra for a ball in Venice in 1951, ought to be secure within an expensive illusion (plate 93). Like so many of Beaton's characters, she has stepped out of a painting, and might be about to step back into it, if that pane of glass is the entry to a looking-glass world. Her reflection is also a reminder of Beaton's narcissism: the dandy, as Baudelaire said, lives and dies in front of a mirror. But the photograph contains a window as well as a mirror and, through that opening, reality breaks in. Cleopatra perhaps dreams of escape into the daylight: is this why she has her hands on the flower pot, inside which a living thing puts down roots in the earth that Venice lacks? Below the window ledge, the water in the canal flows past, as erosive and unstoppable as time.

BOOKS BY CECIL BEATON

The Book of Beauty (Duckworth, London, 1930)

Cecil Beaton's Scrapbook (Batsford, London, 1937)

Cecil Beaton's New York (Batsford, London, 1938) Illustrated from drawings by the author and from photographs by the author and others.

My Royal Past (Batsford, London, 1939; republished by Weidenfeld & Nicolson, London, 1960)

History Under Fire, with James Pope-Hennessy (Batsford, London, 1941)

Time Exposure, with Peter Quennell (Batsford, London, 1941; revised edition, 1946)

Air of Glory (HMSO, London, 1941)

Winged Squadrons (Hutchinson, London, 1942)

Near East (Batsford, London, 1943)

British Photographers (William Collins, London, 1944; reprinted by Bracken Books, 1987) (The original book formed part of the 'Britain in Pictures' series)

Far East (Batsford, London, 1945)

Cecil Beaton's Indian Album (Batsford, London, 1945–6; reprinted in 1991 by OUP as *Indian Diary and Album*, with additional texts by John Nicholson and Jane Carmichael)

Cecil Beaton's Chinese Album (Batsford, London, 1945–6)

India (Thacker & Co., Bombay, 1945)

Portrait of New York (Batsford, London, 1948; revised, second edition of his 1938 book. Includes new dust jacket and different pictures, and title.)

Ashcombe (Batsford, London, 1949; reprinted by The Dovecote Press Ltd, Dorset, 1999)

Photobiography (Odhams, London, 1951; also published in America by Doubleday, New York, 1951)

Ballet (Allen Wingate, London, 1951)

Persona Grata, with Kenneth Tynan (Allen Wingate, London, 1953)

The Glass of Fashion (Weidenfeld & Nicolson, London, 1954; also published in America by Doubleday, New York, 1954; in France as *Cinquante Ans d'Elégances et d'Art de Vivre*, Amiot-Dumont, Paris, 1954; and in Japan by Kern Associates, Tokyo, 1954)

It Gives me Great Pleasure (Weidenfeld & Nicolson, London, 1956; also published in America as *I Take Great Pleasure*, John Day, New York, 1956)

The Face of the World (Weidenfeld & Nicolson, London, 1957)

Japanese (Weidenfeld & Nicolson, London, 1959)

Cecil Beaton's Diaries: 1922–1939 The Wandering Years (Weidenfeld & Nicolson, London, 1961; also published in America by Little Brown, Boston, 1961)

Quail in Aspic (Weidenfeld & Nicolson, London, 1962; also published in America by Bobbs Merrill, New York, 1963)

Images, with a preface by Dame Edith Sitwell and an introduction by Christopher Isherwood (Weidenfeld & Nicolson, London, 1963; also published in America by Bobbs Merrill, New York, 1963)

Royal Portraits, with an introduction by Peter Quennell (Weidenfeld & Nicolson, London, 1963; also published in America by Bobbs Merrill, New York, 1963)

Cecil Beaton's 'Fair Lady' (Weidenfeld & Nicolson, London, 1964)

Cecil Beaton's Diaries 1939–1944 The Years Between (Weidenfeld & Nicolson, London, 1965)

The Best of Beaton, with an introduction by Truman Capote (Weidenfeld & Nicolson, London, 1968)

My Bolivian Aunt (Weidenfeld & Nicolson, London, 1971)

CECIL BEATON'S DIARIES

Cecil Beaton's Diaries: 1944–1948 The Happy Years (Weidenfeld & Nicolson, London, 1972; also published in America as *Memoirs of the Forties* McGraw-Hill, New York, 1972; and in France as *Les Années Heureuses*, Coedition Albin Michel-Opera Mundi, Paris, 1972)

Cecil Beaton's Diaries: 1948–1955 The Strenuous Years (Weidenfeld & Nicolson, London, 1973)

The Magic Image: *The Genius of Photography from 1839 to the Present Day*, with Gail Buckland (Weidenfeld & Nicolson, London, 1973)

Cecil Beaton's Diaries: 1955–1963 The Restless Years (Weidenfeld & Nicolson, London, 1976)

Cecil Beaton's Diaries : 1963–1974 The Parting Years (Weidenfeld & Nicolson, London, 1978)

Self Portrait with Friends, Richard Buckle (ed.)

(Weidenfeld & Nicolson, London, 1979; also
published in America by Times Books, New York,
1979; reprinted by Pimlico, 1991)

*The Unexpurgated Beaton: The Cecil Beaton Diaries
as they were written*, Introduced by Hugo Vickers
(Orion, September 2003)

Beaton in the Sixties: More Unexpurgated Diaries,
Cecil Beaton, introduced by Hugo Vickers
(Weidenfeld & Nicolson, October 2004)

PUBLICATIONS FEATURING BEATON'S ILLUSTRATIONS

The Twilight of the Nymphs, Pierre Louÿs
(Fortune Press, London, 1928)

Wings on her Shoulders, Katharine Bentley Beauman
(Hutchinson, London, New York, Melbourne, 1943)

Face to Face with China, Harold Rattenbury (Harrap,
London, 1945)

The School for Scandal, Richard Brinsley Sheridan
(The Folio Society, London, 1949)

Before the Sunset Fades, The Marchioness of Bath
(Longleat Estate Company, 1951)

Second Son, an autobiography, with an introduction
by Paul Bowles (Peter Owen, London, 1972)

Salisbury: *a new approach to the city and its
neighbourhood*, Hugh Shortt (ed.) (Longman,
London, 1972)

The Importance of Being Earnest, Oscar Wilde (The
Folio Society, London, 1960)

First Garden, C.Z. Guest (Putnam, New York, 1976)

Best of the Saturday Book, John Hadfield (ed.)
(Hutchinson, London, 1981)

FURTHER READING

Cecil Beaton, an appreciation by Osbert Sitwell,
exh.cat. (Cooling Galleries, London, 1927)

Beaton Portraits, with a foreword by Roy Strong,
exh.cat. (National Portrait Gallery/HMSO,
London, 1968)

Fashion: An Anthology by Cecil Beaton, exh.cat.
(Victoria & Albert Museum/HMSO, London,
1971)

The Photographs of Sir Cecil Beaton, exh.cat.
(Impressions Gallery of Photography, York, 1973)

Cecil Beaton: Stage and Film Designs, Charles
Spencer (St Martin's Press, New York, 1975)

Beaton, edited and with text by James Danziger
(Secker & Warburg, London, 1980)

Cecil Beaton, Phillipe Garner (The *Great
Photographers* series, Collins, London 1983)

Cecil Beaton: The Authorised Biography, Hugo Vickers
(Weidenfeld & Nicolson, London, 1985; revised
and updated edition *Cecil Beaton*, Hugo Vickers,
Weidenfeld & Nicolson, 2002)

'*Introduction*' *Cecil Beaton and Friends*, Peter
Quennell (Michael Parkin Fine Art, London,
1985)

Cecil Beaton, David Mellor (ed.), exh.cat. (Barbican
Art Gallery/Weidenfeld & Nicolson, 1986;
reprinted, Little Brown, Boston, 1986)

Beaton in Vogue, Josephine Ross (Thames & Hudson,
London, 1986)

Cecil Beaton: The Royal Portraits, Roy C. Strong
(Thames & Hudson, London, 1988)

Greta and Cecil, Diana Souhami (Jonathan Cape,
London, 1994; revised edition, Weidenfeld &
Nicolson, 1999)

*Loving Garbo: The Story of Greta Garbo, Cecil Beaton
and Mercedes de Acosta*, Hugo Vickers (Jonathan
Cape, London, 1994)

SALES

Sotheby's, London and New York

Photographic Images and other material from the
Beaton Studio
Sotheby's Belgravia: 21 November 1977, 30 June
1978, 26 October 1979
Sotheby's Park Bernet, New York, 9 November
1978

Christie's, Manson and Wood

(Contents of) Reddish House, Broadchalke,
Wiltshire
Christie's, Manson and Wood, London: 9–10 June
1980

Stage and Costume Designs, Portraits, Fashion
Drawings and Landscapes from the studio of the
late Sir Cecil Beaton, CBE: 7 June 1984
Stage and Costume Designs, Fashion Drawings,
Landscapes, Portraits and Sketch-Books by Sir
Cecil Beaton, CBE (from the estate of the late
Miss Eileen Hose): 21 June 1988

ACKNOWLEDGEMENTS

In New York I should like to acknowledge the tireless help of Jennifer Gyr, who reprised the unfailing help provided in my previous Anglo-American exhibition and book *Horst: Portraits* (1999), and Cynthia Cathcart, Director at the Library and Information Services at Condé Nast Publications who provided valuable index card information. I am grateful to the foresighted New York-based collector Paul Walter who attended all the Beaton estate sales in England and New York and purchased many key items, which he has generously lent to this exhibition. My thanks also to the photographer Robert Puglisi, who expertly copied these works onto transparency for inclusion in this book.

In London my main research has been divided equally between the *Vogue* Library in Vogue House and I cannot thank the staff sufficiently for the help it provides, especially Janine Button and Robin Muir. More particularly at *Vogue* we would like to thank Nicholas Coleridge, Stephen Quinn and Alexandra Shulman who all gave their seal of approval at an important early stage of the project. The staff at the Beaton Archive at Sotheby's have made me welcome on a number of fruitful research missions, particularly Lydia Cresswell Jones who has managed the archive there for nearly all of its existence. Other help at Sotheby's came from Lucinda Blythe, Dr Juliet Hacking and Sue Daly. I spent several days viewing the huge archive of Beaton prints made from his original negatives taken for the Ministry of Information during the war, now housed at the Imperial War Museum where Hilary Roberts and her staff wheeled out groaning trolleys laden with the many Beaton albums in which his work is assembled. The photographic service that the Museum supplies makes a Beaton print available to any interested visitor.

I should also like to thank my many colleagues at the National Portrait Gallery: our Director, Sandy Nairne; Clare Freestone, the Assistant Curator of Photographs who has helped me beyond the call of duty, as well as finding time to catalogue our Beaton archive onto an accessible online resource. Exhibitions Manager Claire Everitt has worked tirelessly in organising the loans and helping to shape the book and the exhibition. The exhibition design is the result of a very happy collaboration with Annabel Dalziel who listened patiently to all my suggestions and produced a classic, yet exciting, hang. For the publication, most help was provided by my Editor Anjali Bulley, and the catalogue was beautifully designed by Ray Watkins. I also thank Ruth Müller-Wirth, Pim Baxter, Naomi Conway, John Haywood, Hazel Sutherland and the PR and Development team, as well as David Saywell and the IT team, and Jan Cullen and the Education Department for organising a stimulating programme of lectures. I am also grateful to Constantia Nicolaides, who helped as a volunteer to transcribe Beaton's incomplete sitters' books. Hugo Vickers, Beaton's official biographer and expert editor of Beaton's unexpurgated diaries, provided enormous encouragement and made generous loans; Penelope Smaile, daughter of Curtis Moffat; Mr and Mrs Robert Lassam in Bath and Angela Williams and finally, my partner Rosalind Crowe for encouragement and advice throughout this project.